THE
CADD DEPARTMENT
A Guide to Its Successful Organization and Management

Katherine Panchyk
Richard Panchyk

T0142976

VNR VAN NOSTRAND REINHOLD
New York

Cover: Plan of Canary Wharf, London, England. Used with permission of
Weidlinger Associates.

Copyright © 1991 by Van Nostrand Reinhold

Library of Congress Catalog Card Number 91-11693
ISBN 0-442-00509-1

Manufactured in the United States of America

Published by Van Nostrand Reinhold
115 Fifth Avenue
New York, New York 10003

Chapman and Hall
2-6 Boundary Row
London, SE1 8HN

Thomas Nelson Australia
102 Dodds Street
South Melbourne 3205
Victoria, Australia

Nelson Canada
1120 Birchmount Road
Scarborough, Ontario M1K 5G4, Canada

16 15 14 13 12 11 10 9 8 7 6 5 4 3 2 1

Library of Congress Cataloging-in-Publication Data

Panchyk, Katherine, 1946–
 The CADD department: a guide to its successful organization and
 management/Katherine Panchyk, Richard Panchyk.
 p. cm.
 Includes index.
 ISBN 0-442-00509-1
 1. Engineering design—Data processing—Management. I. Panchyk,
Richard. II. Title.
 TA174.P36 1991
 620′.0042′0285—dc20 91-11693
 CIP

Contents

Preface / vii

Chapter 1. Initial Decisions / 1

A. Subdirectories as Organizers / 3
B. Project/File Logging / 5
C. Networking versus Standalone / 7
D. Purchase of Outside CADD-Support Software / 11
E. Computer File Management / 13
 Summary / 17

Chapter 2. Before Beginning Work / 18

I

A. CADD Planning / 18
B. The Importance of a Good Numbering System / 21
C. Pitfalls of Using Directories as Project Separators / 24
D. Where is the Original? / 25
E. Renaming the Interdepartmental Use / 26

II

A. Safeguarding the Drawing File / 26
B. Second Backups / 27
C. Record Sets / 29
D. Automatic Saving / 29
 Summary / 29

Chapter 3. Communication in the CADD Department / 31

A. The Physical Environment / 33
B. Word of Mouth / 37
C. Documentation / 40
 Summary / 42

Chapter 4. CADD Drawing Standards / 44

A. Layer Assignments—Grouping of Elements / 45
B. Selecting Text / 49
C. Building a Symbol Library / 50
D. Using Entities Other than Symbols / 54
 Summary / 55

Chapter 5. The CADD Department: The CADD Manager and Staff / 56

A. Who Should Run the CADD Department? / 56
B. Selection of CADD Drafters / 58
C. CADD Drafters' Training Program / 58
D. Training the Rest of the Office / 62
E. Information Management—Giving Work to the CADD Department / 67
 Summary / 68

Chapter 6. You Can Finally Begin / 70

A. What to Look for in a Menu System / 71
B. After Choosing a Menu System / 76
 Summary / 77

Chapter 7. A Brief Guide to AutoCAD for Managers / 78

A. What You Have to Understand About AutoCAD Before Beginning / 78
B. The Draw and Edit Commands / 89
C. The More Complex Commands / 93
 Summary / 96

Chapter 8. The Hard Copy: Plotting the Drawings / 97

A. Pen Plotters / 100
B. Pencil Plotters (Pen/Pencil) / 102
C. Laser and Electrostatic Plotters / 103
D. Sending Work Out to Be Plotted / 104
E. Pen Assignments and Plotting Hangups / 106
 Summary / 110

Chapter 9. Disaster Handling / 111

A. Safeguards Against Disasters / 111
B. Legal Aspects / 119
 Summary / 120

Chapter 10. Smooth Sailing? / 121

A. CADD Software Changes/Upgrades / 121
B. Communication Among Consultants / 122
C. Scanning / 125
D. Improvements / 126
E. Finances/CADD Payback / 128
F. Information Management / 128
G. The Future of CADD / 129
 Summary / 130

Index / 133

Registered Trademark List

AutoCAD is a registered trademark of Autodesk, Inc.
dBASE is a registered trademark of Ashton-Tate Corp.
PCDOS is a registered trademark of IBM Corp.
UNIX is a registered trademark of AT&T Corp.
Norton Integrator and Norton Speed Disk are registered trademarks of Peter
 Norton Computing
Ventura is a registered trademark of Ventura Software Inc.
Lotus 123 is a registered trademark of Lotus Development Corp.
Wams is a registered trademark of Weidlinger Associates
Nth Engine is a registered trademark of Nth Graphics, Ltd.
Metheus is a registered trademark of Metheus Corp.
Xtree is a registered trademark of Executive Systems Inc.
Quark Express is a registered trademark of Quark Inc.
Sun's PC Network File System is a registered trademark of Sun Microsystems
Novell is a registered trademark of Novell Inc.
Banyan-Vines is a registered trademark of Banyan Systems
PCTOOLS is a registered trademark of Central Point Software, Inc.

Preface

Although the computers have been installed, and the staff is fully trained in CADD, you may find that you are still far from the goal you had envisioned for the firm: an efficient and functional new link in the E/A production cycle.

Converting to an automated system can boost efficiency, but only when serious thought is given to reorganization. It is not just the CADD software that will make a difference. The drafters will now have to adjust. New positions will be created. Storage systems will be altered. Work methods and habits will have to change. Procedures such as recordkeeping, backups, naming conventions, information flow, symbol libraries, customized standards, menus, and plotting assignments must all be set and followed.

Rushing into production work before these are decided upon can create general havoc, and is likely to lead to ultimate disillusionment with the new CADD system.

The CADD Department is a guide to using CADD for firms and professionals, ranging from a two-person team to a 20-and-up workstation setup with a CADD systems manager running the department. This book will point out various techniques in organizing the CADD department, and will explain the traps and pitfalls to watch out for. In addition, the quick guide to AutoCAD can speed familiarity with the system, with advice as to what you must know about AutoCAD, such as the range of commands, from the easiest to the most complex, and the customized commands used to suit *your* specific needs.

This guide is a comprehensive overview of running successfully

on CADD in the A/E environment. Particular emphasis is laid on AutoCAD, as it is one of the most widely used PC-based software on the market, but most advice is generic and useful for almost any type of system.

This book is meant to be a guide to successful reorganization. We believe that every professional who has ever struggled with making CADD work to the fullest of its capabilities will benefit from it. The greatest stumbling block is not learning AutoCAD or any particular CADD program, but incorporating CADD effectively into the production system of the office.

The CADD Department is a way to get as much as possible from CADD systems without having to read twenty-pound manuals or complex technical books. Written for middle and upper managers of structural, civil, and mechanical engineering firms, as well as architectural firms, the book can and should also serve as a guide to CADD in general (and to AutoCAD) for less frequent users or engineers/architects who will work in conjunction with the CADD department. Even those not directly involved with CADD, but who oversee specific projects, should be familiar with storage and organizational systems. Reading this book will allow key personnel to advise the CADD department and understand how it operates.

Specific products are not investigated in depth in this guide. Our purpose is not to inundate the reader with data, reviews, and prices, which will all be outdated in a matter of months anyway, but to help make CADD a functional part of the firm's production cycle. Advice is given as to how to approach and evaluate various new software products, plotters, etc. that are constantly being introduced to the market. Emphasis is placed on greatly improving efficiency, adapting smoothly, and increasing both intradepartmental and interdepartmental interaction.

Chapter 1

Initial Decisions

The first step a company takes toward converting from manual drafting to CADD (computer aided drafting and design) production is ordering the necessary hardware and CADD software.

Making decisions on computer hardware is by no means easy. The best combination of components at any given time may be undesirable in just a year. Because of the large selection of well-known names (as well as clones), recommending a specific model here is unwise. Instead, suggestions will be made as to what capabilities are important.

At demos or computer shows you might be greatly impressed by talking computers or features such as multitasking (the ability of a computer to process more than one program at a time) and windows. Users who work on spreadsheets, desktop publishing, word processing, CADD, and maybe even analysis programs can benefit from multitasking. Keep in mind, however, the true function of the workstation. If it is to be a full-time drafting station, the multitasking feature diminishes in importance.

One of the crucial features to look for is speed. A CADD station can never be too fast. The computer's speed determines how fast tasks are performed. There is nothing more annoying than staring at a monitor, waiting for the machine to complete an operation. The speed of the processor also determines how fast screens will be regenerated, zoom commands will be displayed, etc. Zooming (enlarging or reducing an image on the screen) speed can be further enhanced by hardware add-ons such as Nth Engine or Metheus, which eliminate nearly all zoom-related regeneration.

The next item of importance is resolution. A CADD workstation

should not have poorer than 800 × 600 resolution. This lower figure is acceptable for part-time users (engineers or architects) who may spend much of their time at meetings or with clients. A resolution of 1024 × 768 or greater is recommended for full-time workstations. Poor resolution itself can be enough to discourage CADD use, and can cause considerable eye discomfort.

The monitor size may be 13″ for part-time stations, but for full-time stations a 16″ to 19″ range is preferable as it is easier to work with. Larger screens offer a better overall view of a drawing and minimize dependency on zooming.

Data input, meanwhile, is achieved with either a digitizing tablet or a mouse. While opinions may vary on which method is better or faster, a digitizing tablet may, in fact, be the better option. With a well-designed tablet overlay (menu), selections can be made quickly (with a digitizing puck). In addition, digitizing pucks come with multiple buttons that can be programmed with commands. The commands can be issued without even a glance away from the screen.

When a mouse is used, all commands must be selected from screen or pull-down menus. This procedure often requires the user to make several choices before the command is finally issued. The mouse usually has only one or two programmable buttons (though some newer models have multiple buttons) and the crosshairs on the screen are harder to control than with the smooth consistency of a high quality digitizing puck. Nevertheless, a mouse is an acceptable alternative when space is limited (a digitizer usually takes up 15″ × 15″), the budget is limited, or the machine is utilized as a part-time CADD station.

Initial problems with CADD software and configuration conflicts are usually solved by the dealer or installer. Software installation is sometimes left to the user, but with the aid of step-by-step guidance from manuals or installation programs, this can be accomplished painlessly.

Most problems are encountered when the office lacks the expertise on how to set up CADD operations. Without this expertise, firms may set up operating procedures which are ineffective and may be difficult to alter later on. The choices made early on form a foundation for later decisions. Once the foundation is set, it will be built upon to expand and strengthen the CADD department. A

weak, unorganized foundation will crumble under future expansion.

A. SUBDIRECTORIES AS ORGANIZERS

One early decision involves the distribution of CADD and related software within the computer's hard drive. It is best to use each computer's subdirectory capabilities to help organize CADD software as well as related support files. The following is a suggested directory tree for CADD and its support files (see Figure 1-1):

C:\CAD. The CADD software and its own support files should reside in a directory of their own. This will prove helpful when new versions of the CADD software are purchased. Reloading by deleting the directory's contents and replacing them with the new version

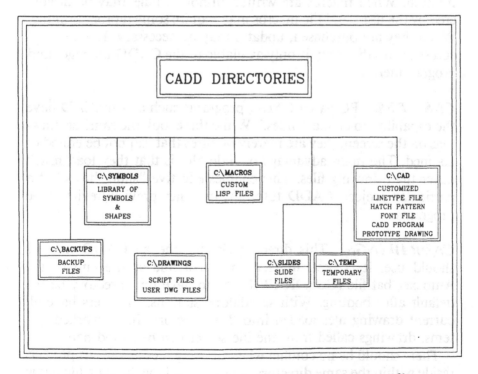

Figure 1-1. Suggested directory tree for CADD software and support files.

is speedy and is a good alternative to having to sort files to be deleted or saved. User CADD work should not be kept here.

C:\SYMBOLS. This directory should be set aside as the library for all the symbols, custom text fonts, shapes, typical details, etc. CADD work should not be done within this directory. However, all drawn objects or groups of objects that will be needed consistently, job after job, belong here. If the number of bytes used here is too high, byte-intensive files such as typical details can be stored on floppy disks and loaded as needed. When accessing symbols to be inserted into drawings being edited, the path to the symbols directory should be used. For example: "INSERT" C:\SYMBOLS\NAME OF SYMBOL.

C:\MACROS. Macros, or automatic drawing routine programs (literally "quick draw") merit storage in their own directory. Macros are often written in computer language and may need updating or revision. When macros are written in-house, bugs may be discovered by the users and the macros may require some reprogramming. When they are purchased, updates may be necessary. It is better if access to this directory is only available to the CADD manager and programmer.

C:\SLIDES. PC-based CADD programs such as AutoCAD have the capability to create "slides." While these look the same as drawings on the screen, they are merely pictures that can not be edited or zoomed. The main advantage of slide files is that they load much faster than drawing files. This enables effective "slide shows" of a particular project, CADD tutorials, or other preview/review type programs.

C:\DRAWINGS. This directory is the one all CADD drafters should use. It is best, in fact, to add a line at the end of the Autoexec.bat file (CD\DRAWINGS) to have this directory be the default after booting. With standalone stations, the users have all current drawing files loaded into this directory. In networked systems, drawings called from the file server can be stored here.

There should be no conflict when drawing files of various projects reside within the same directory. The prefix of the drawing file name

clearly indicates project identification of each drawing (see Chapter 2).

C:\BACKUPS. This directory is set up to receive backup versions of current or recently worked on drawings. Sending a saved version of a drawing automatically to a backup directory via a menu macro (see Figure 2-5) is a good safeguard against user errors. For instance, a user may accidentally delete all files in the C:\DRAWING working directory before updating the floppy disk. This is the time when the C:\BACKUP directory can be accessed to retrieve the deleted files.

Because drawing and backup files tend to accumulate and use up computer space, they should be deleted at intervals set by the CADD manager (usually after all work on the system has been backed up by the user as well as the CADD manager; i.e., two separate floppy disk backups).

C:\TEMP. A temporary directory is handy to have. It can have many applications. It should always be used when all of a project's drawings are loaded for the purpose of creating plot files or drawing interchange files. It is especially important in standalone PCs since, if an error exists on a diskette, the drawing may load over an existing drawing in the working directory, thus "poisoning" it. Through use of C:\TEMP, this situation can be avoided.

B. PROJECT/FILE LOGGING

For a company just starting out on CADD, project logging may be unnecessary. As the CADD department grows, though, and the number of projects drawn through CADD increases, project logging and tracking of work, as well as limiting access to various files, may become a requirement.

The best way to accomplish this is with CADD-tracking software. There are a good number of these on the market. Some of the tracking programs are complex to set up and use, while others are straightforward (see Figure 1-2).

Remember that complex programs, unnecessary access codes, and frequent log-on/log-off requirements are time consuming. Evaluation of the firm's needs with regard to CADD tracking is an

important first step. Some cases where tracking software is useful are given below:

- The client is being billed CADD overhead time, and "proof" is required.
- Accounting needs to have the number of man-hours spent on certain projects.
- Access to some projects or computer directories must be restricted.
- Tracking time spent on drawings enables efficiency calculations to be made.

The traditional time card has always been the recordkeeping method drafters employed to charge time to various projects. A computer log printout, however, is more official and impressive looking, especially in billing clients. The problem arises when inconsistencies exist between time-card-charged time and CADD-tracking time.

For instance, a CADD drafter may mistakenly log-on to the

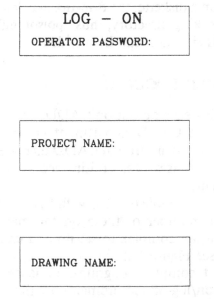

Figure 1-2. Example of a simple log-on prompt.

wrong job number or forget to log-off at lunchtime or in the evening. While some log programs have an automatic log-off after a given number of hours have elapsed, inaccuracies may still exist.

There are ways to set up tracking software that stops the user and asks for a log code every time the drawing editor is entered. This can both waste time and annoy CADD drafters, who may be in and out of drawing files many times every day. Even when this rigidly controlled system is employed, accuracy can be hampered. A CADD drafter may be logged-on to a drawing yet be away from his workstation at a meeting or on a coffee break. Whether the log-on/log-off is voluntary or program driven, the log reports should always be reviewed by the accounting department and edited for errors.

Since CADD work usually involves working drawings and the CADD users can most likely be trusted not to use unauthorized directories or corrupt so called unknown files, access restrictions are usually unnecessary. Only for classified government work, where security clearance is required, should access restrictions be implemented.

Most frequently, the number of man-computer hours on a particular project is the only required information from logging systems. This is most easily accomplished by a log-on system that merely requires stating project and codename of user and log-off when work on the project is complete (or at the end of the work day).

Log reports generated at each workstation can then be merged and totals per drafter or per project can easily be extracted.

C. NETWORKING VERSUS STANDALONE

At the initial stages of conversion from manual to CADD drafting, top management may be skeptical or wary of switching entirely to CADD production. Thus the initial stages of conversion might involve only one or two workstations with minimal hardware requirements to keep costs down.

When this is the case, uncertainty will abound. Not surprisingly, only the boldest of project managers will opt to put his project on the automated system. Among the others will be skeptics who keep CADD work under close scrutiny and track the failures and successes of the test implementation on CADD.

The first project chosen for CADD is bound to be looked at as the

test case. It is with the first real CADD production work that the shortcomings of the system, or lack of foresight, become apparent. With each additional project done on CADD, new needs arise and new procedures or ideas can be incorporated into the system.

It is important to understand that the key to successful CADD operations is not merely the degree of fluency of the CADD drafter in CADD commands. Instead, success depends upon how well the CADD department and its operations are organized.

Not all firms use this gradual implementation of CADD. Some large consultants and designers, realizing the demand for CADD drawings by clients, may simply order and install multiple workstations with the intent of doing as many projects on CADD as soon as possible.

In either case, the question of networking eventually comes up. The people supporting the all-or-nothing push to CADD may decide initially on networking the CADD system, while the gradualists, as they acquire more and more workstations, may suddenly realize that networking is a viable solution to their organizational problems. For both situations, a thorough search must be conducted to find a network suitable for the needs of the firm.

While the concept of networking is generally the same (see Figure 1-3), there are important differences among the various systems available. Banyan-Vines, Novell, and Sun's PC-Network File System (NFS) have differences that may be important to the user. Even after a certain system is chosen, there are still configuration options, menu-driven aids, or management tools to look at, all of which might enhance the system's performance.

Basically, a network consists of a centralized file storage center, the *file server*, with a number of workstations linked together, as well as one or more printers and/or plotters. The idea is that each user can access files from the file server, send plots, and communicate with others without moving from station to station. The way a system functions as a whole is what distinguishes one network from the other.

Network Management

What level of difficulty does system management attain? Is there management software to make complex UNIX commands easy to use? Is there a file management and locking program to assure that

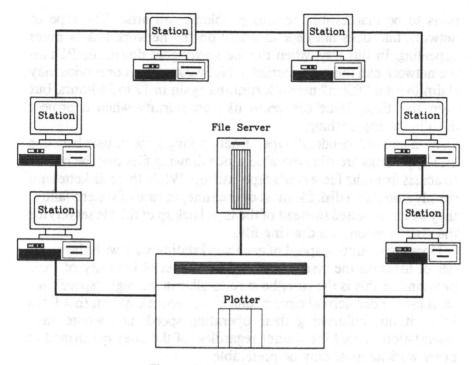

Figure 1-3. The concept of a network.

files are retrieved and returned to the appropriate directories in the main file server? Are there safeguards against having two users working on the same drawing simultaneously? Will the system accept basic DOS commands, or does UNIX have to be learned in order to perform the operations?

While preferences vary, and may depend on the user's past exposure to computers, it is most likely that a user-friendly operating system such as DOS or a menu-driven version of UNIX will be favored for CADD systems. Remember that CADD is a tool used by designers and drafters who are more conversant with analysis, design, and sketching than with the nuts and bolts of operating systems.

Independence versus Interdependence

What happens when the server or the entire network goes down? Are all workstations down as well, or can they still function as individual PCs? When a network system failure causes all worksta-

tions to be inaccessible, serious problems can arise. The type of network that does not depend solely on the network link is more appealing. In this way, when the file server goes down, the PCs on the network can function normally. Network support or service may claim to get a "fallen" network running again in 12 to 24 hours, but even this time frame can seem like an eternity when a project deadline is approaching.

With an "independent" type of networking system, user backups on floppy disks are still advisable, since drawing files may be harder to access from the file server's tape backup. While these diskettes are simply stored in a disk file most of the time, in case of system failure they can be accessed (instead of the tape backup of the file server) for the latest version of a drawing file.

Does the operating speed of each workstation vary with the number of users on the system and with the level of intensity of their program? If this is the case, be sure to allocate enough "speed" for each user under normal circumstances. A network system that links PCs without influencing their operating speed; i.e., where each workstation's speed is constant regardless of the tasks performed at other workstations, may be preferable.

Quality of the Network

This is very important. A network with inferior components or untested performance can do more harm than good. Although it is a potential organizational and time saving tool, when unreliable, hard to manage, or limiting, it becomes a burden.

Networking Pros and Cons

The best way to decide whether or not networking is the right choice is to look seriously at how much networking's pros weigh against its cons for the A/E firm's needs.

Pros:

- All users have automatic access to the latest version of a drawing file.
- Easy automatic system backups on tape straight from file server.

- Plots can be sent from every workstation.
- Centralized support software capabilities.
- System files and operations can be reviewed.
- It can be managed centrally by CADD managers.
- With management software, users are guided through procedures.
- Multitasking is possible.
- DOS and UNIX can be linked.
- Various types of CADD software, structural analysis programs, desktop publishing, word processing, spread sheets, and database programs can be interfaced.

Cons

- Potential exists for breakdown of the entire system.
- Complexity of systems administration; it is time consuming and may require a special person on the job.
- Poor or no management software can result in user errors that can lead to serious problems.
- Slowdown of the entire system may occur with intensive use of workstations and sharing of CADD software.

D. PURCHASE OF OUTSIDE CADD-SUPPORT SOFTWARE

Third-party software is available for many CADD systems, especially the most popular ones, such as AutoCAD. While AutoCAD, for example, is very versatile as well as greatly sophisticated, it is suggested that thought be given early on as to what additional packages would benefit the CADD setup. Some important types of outside software are detailed below.

Custom Menu Systems. It is best to select an appropriate menu system at the onset. Once work on CADD begins, users become reluctant to change menu systems, an effort which would require the learning of new command selection processes.

Parts Libraries. Purchase of packages with symbols, details, architectural shapes, and structural shapes should be considered.

Text Editors. These are useful in aiding the editing of text in CADD drawings.

Macros. Programs which do parametrics suitable for the firm can help. In such programs, objects are drawn automatically following prompting for dimensions or specifications; for instance, an elevation of a door is drawn after prompts for height and width are answered. Macros are useful in laying out ducts, structural grid piping, mapping, etc.

Plot Spoolers. These free up the computer during plotting.

Zoom Aids. These help to speed up display operations.

Custom Fonts. These are used to allow for alternative styles of text for special presentations or title blocks.

Database Managers. These help manage and utilize all the information within CADD drawings, making material takeoffs, area calculations, etc., automatic.

Information Management. Use of a program such as dBase can help organize and sort drawing data, creating both a permanent and a working library of projects and specifications.

CADD Tracking Software. This is often part of log-on/log-off programs.

Translators. These are used to transfer data or programs between various types of CADD systems, or between analysis programs and CADD.

Structural Analysis Packages. These structural design packages can export graphic data to a CADD system or import graphics done in CADD to speed structural input for analysis.

Third-party software should be carefully evaluated; sometimes a demo is needed. Even when this is done, software products often are not what they were promised to be, and are ineffective or difficult to use. A bad choice in software may require several calls to the

distributor/programmer for an explanation. Support software is sometimes marketed by small operations, and there is predictably very little in the way of instruction included.

E. COMPUTER FILE MANAGEMENT

Complex networked systems based on the UNIX operating system need a systems administrator to manage files, directories, programs, etc. Nevertheless, the CADD drafters should have certain basic computer management skills. The commands and procedures differ with the system employed, or the menu driven version of that system.

It is always a good idea to have a working knowledge of DOS, the system now most widely employed with PCs.

The following operations should be known by anyone working with CADD:

Listing

- Listing the directory:
 DIR
- Listing only drawing files:
 DIR*.DWG
 (see Figure 1-4)
- Listing only projects with 45- prefix:
 DIR 45-*.DWG
 (see Figure 1-5)
- Listing only the 45- drawings that are sections:
 DIR 45-SEC*.DWG
 (see Figure 1-6)

Copying

- Copying a file from the hard drive to a floppy disk:
 COPY 45-SEC5.DWG A:
- Copying a drawing from a floppy disk to the hard drive:
 COPY A:45-SEC5.DWG
- Duplicating a drawing by copying it to a file with another name:
 COPY 45-SEC5.DWG 45-SEC6.DWG

```
C:\DRAWINGS!
.DIR *.DWG

 Volume in drive C is C
 Directory of  C:\DRAWINGS

 45B-RDS   DWG      6243   12-27-89    9:25a
 45B-PG    DWG     13170    1-31-90   10:56a
 45-S1     DWG    132938    4-06-90   10:39a
 45-S15    DWG     22327    4-09-90   10:51a
 54-GR     DWG     22327    4-09-90   10:51a
 45B-STAG  DWG      3997   12-27-89   10:27a
 45-SEC1   DWG    250290    4-06-90   11:08a
 54-S7     DWG     41560    4-10-90    1:24p
 45-SEC2   DWG    105446    4-06-90   11:44a
 45-S16    DWG     41560    4-10-90    1:24p
 45-S3     DWG    479853    4-06-90    1:24p
 54-S9     DWG     39281    4-10-90    4:03p
 45-S18    DWG     39281    4-10-90    4:03p
 58-SK5    DWG    154536    4-17-90    1:18p
 45-TITLE  DWG     23297    6-27-89   10:29a
 45-S23    DWG     76016    4-16-90    6:06p
 45-SEC8   DWG    157969    4-17-90   11:52a
 45-SEC7   DWG      4418    2-22-90   11:34a
 45-S22    DWG    154536    4-17-90    1:18p
 43-3F     DWG    132938    4-06-90   10:39a
 45-DET1   DWG      2537    1-23-90    9:57a
 43-PF     DWG    250290    4-06-90   11:08a
 45-SEC5   DWG      4738    2-05-90    1:11p
 43-PR     DWG    105446    4-06-90   11:44a
 45-DET3   DWG     59074    4-16-90    6:05p
 45-DET2   DWG     14033    3-23-90   10:38a
 43-FDN    DWG    479853    4-06-90    1:24p
       27 File(s)   14358528 bytes free

C:\DRAWINGS!
.
```

Figure 1-4. Directory of *.DWG.

Copying properly is especially important to know. Without a basic understanding of the copy command, a user may copy an outdated version of a file over the latest version.

Changing Drives

- A: puts the operator into A:\ drive to list directories, work, or delete files.
- C: (or D: when there are split hard drives) puts the operator back into the computer's hard drive.

```
C:\DRAWINGS!
.DIR 45-*.DWG

Volume in drive C is C
 Directory of  C:\DRAWINGS

45-S1      DWG    132938   4-06-90  10:39a
45-S15     DWG     22327   4-09-90  10:51a
45-SEC1    DWG    250290   4-06-90  11:08a
45-SEC2    DWG    105446   4-06-90  11:44a
45-S16     DWG     41560   4-10-90   1:24p
45-S3      DWG    479853   4-06-90   1:24p
45-S18     DWG     39281   4-10-90   4:03p
45-TITLE   DWG     23297   6-27-89  10:29a
45-S23     DWG     76016   4-16-90   6:06p
45-SEC8    DWG    157969   4-17-90  11:52a
45-SEC7    DWG      4418   2-22-90  11:34a
45-S22     DWG    154536   4-17-90   1:18p
45-DET1    DWG      2537   1-23-90   9:57a
45-SEC5    DWG      4738   2-05-90   1:11p
45-DET3    DWG     59074   4-16-90   6:05p
45-DET2    DWG     14033   3-23-90  10:38a
       16 File(s)   15593472 bytes free

C:\DRAWINGS!
.
```

Figure 1-5. Directory of 45-*.DWG.

Changing Directories

- When in a directory called C:\CAD, typing CD\DRAWINGS places user into C:\DRAWINGS. CD\SLIDES places user in C:\SLIDES.
- CD\ returns the user to root or C:\.

```
Volume in drive C is C
 Directory of  C:\DRAWINGS

45-SEC1    DWG    250290   4-06-90  11:08a
45-SEC2    DWG    105446   4-06-90  11:44a
45-SEC8    DWG    157969   4-17-90  11:52a
45-SEC7    DWG      4418   2-22-90  11:34a
45-SEC5    DWG      4738   2-05-90   1:11p
        5 File(s)   15593472 bytes free

C:\DRAWINGS!
.
```

Figure 1-6. Directory of 45-SEC*.DWG.

Deleting Files

- DEL 45-SEC5.BAK deletes one file, or DEL 45-*.BAK deletes all 45- files with the extension .BAK
- DEL *.* deletes everything in the current directory.

A file or files might occasionally be deleted by mistake. In this case a utility such as Norton Quick Unerase, developed by Peter Norton, can be employed to retrieve the file(s). This has to be done right away, though. Performing other work on the hard drive or floppy disk may cause the deleted file to be corrupted before it can be revived.

Renaming a File:

- To change 45-S1.DWG to 45-S1A.DWG:
 RENAME 45-S1.DWG 45-S1A.DWG

Printing the Directory

- PRINT DIR

Printing an ASCII File

- PRINT NOTES.TXT

Formatting Diskettes

- FORMAT A:

CADD drafters need to know how to format diskettes, since they will be using a great many of them. Careless use of the FORMAT command, however, can lead to disaster (see Chapter 9), e.g., if A: is forgotten, etc.

These basic DOS commands can allow the CADD user to function outside the protective bounds of the CADD program itself.

Programs exist, such as Xtree and PCTools, which allow easier manipulation of files. Others, like the Norton Integrator, perform disk checks and list various file specifications. Contents of directo-

ries can be viewed and tagged, and then erased or copied. These types of programs free users somewhat from their DOS obligations. Some may prefer using these programs strictly because they feel more comfortable in a structured software tool environment.

SUMMARY

There are more decisions to be made beyond the obvious ones concerning the purchase of computers and a CADD system to operate on them.

Choices as to operating procedures must be made at the onset. These choices will form the base from which the CADD department grows and develops.

One decision to be made involves the distribution of CADD and its feeder software within a machine's hard drive. C:\CADD, C:\SYMBOLS, C:\MACROS, C:\SLIDES, C:\BACKUPS, and C:\TEMP all should function as "homes" to specific types of material. Only C:\DRAWINGS should be used by CADD drafters, so as to avoid confusion when looking for or editing a drawing file.

Another decision regards logging systems. Project/file logging systems track work done on projects, and the drafters who are doing that work. These systems may not be necessary for firms just starting with CADD. Growth means more jobs, and in order to keep track of and maybe limit access to certain jobs, a logging system should be introduced.

A basic choice to be made early on is whether to have a networked system or unconnected PCs. There are several issues to be considered when making this decision: whether there is management software available, whether the system is compatible with DOS, and whether all the network's components are high quality. Networked systems are not appropriate for all firms, and pros and cons should be weighed in each particular case.

Picking the desired additional software and introducing it early is desirable. Outside software can add to the main CADD package's effectiveness and efficiency. There is a wide range of software on the market. Unfortunately, even demos can be misleading. Advice from others is a good way to uncover the truth about these programs.

Lastly, a working knowledge of DOS is important in order to manipulate files (erase, copy, etc.). Programs also exist through which these tasks can be accomplished more easily.

Chapter 2

Before Beginning Work

I

As with any project in an architectural or structural engineering office, the scope of the job, progress of drawings, and time scheduling are all set up by the project engineer and the chief drafter. After a preliminary schedule is set and drafters for the project have been selected, the CADD manager and the other professionals working on the project should meet to plan their approach to the presentation/production drawings. If drawings and design schemes are handed out to several different CADD drafters at the same time without planning, disaster can result.

A. CADD Planning

The best time to develop strategies to reduce production time is at the start of a project. A representative floor plan can be chosen and used to generate the other floors, for example.

It is important that engineers, project managers, and the chief drafter be introduced to the office CADD system's capabilities and limitations. If this is not done, engineers may wind up giving work in a sequence that slows rather than speeds progress.

For instance, when a company's CADD system is organized — set up with parametric programs to perform specific functions — it may be very easy to lay out a structural framing plan. In response to prompts that appear on the screen, the grid lines, columns, dimensions, beams, etc. can be drawn in a few minutes. Inefficiencies may result, however, when after 40 framing plans are developed in this

manner, instruction is given to place titles on all drawings. The actual writing of a title takes a minute or so, but loading each drawing into the computer, then waiting for regeneration, and then saving it on a disk (40 individual times!) can be time consuming.

If a project manager then requires the words "Revision II, Section C" to be added to all the titles after the fact, much time will again be wasted. Though changes are unavoidable, engineers, project managers, and chief drafters should know which procedures are simple, and which are not. Once they are aware of CADD capabilities and limitations, they can understand where there is room for late corrections, and where they should try to make sure everything is correct the first time.

Engineers unfamiliar with the CADD system may falsely believe that all tasks can be accomplished with the touch of a few buttons. Orientation sessions may shatter some hopes, but they will rid key personnel of potentially harmful misconceptions. With a solid knowledge of the CADD system, project engineers can better plan the progression of work from the design development stage through the creation of working drawings.

Often, at the start of a project, several preliminary design schemes are drawn and discarded. Scheme A is replaced by Scheme B, which is followed by Scheme C, and so on. If after a few months, while the project is still at an early stage, the project engineers decide that Scheme A was structurally the most feasible, they may find that all drawings and records of that scheme are gone. It is important for engineers to specify which drawings are truly superseded, and which are still viable options.

An example of good CADD planning is bringing one-quarter of a symmetrical building as much up to date as possible before mirroring it, that is, making it complete by copying duplicating the first quarter (see Figures 2-1 a, b, c).

In another case, when 10 framing plans are very similar, rather than make 10 individual plans, drafters should be allowed to work on a master plan of sorts until all the common elements are included. Drafters can then make copies of the master and revise them as called for.

Good coordination between the CADD department manager and engineering or architectural professionals involved can only serve to optimize efficiency.

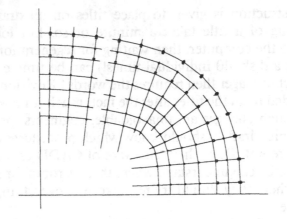

a

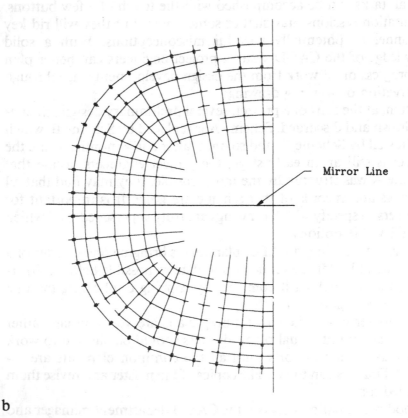

Mirror Line

b

Figure 2-1. (a–c) From a quarter of a framing plan, a symmetrical plan can be generated by mirroring it twice.

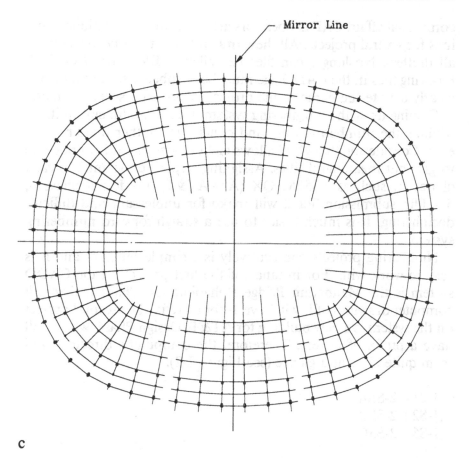

Mirror Line

c

Figure 2-1. (*continued*)

B. THE IMPORTANCE OF A GOOD NUMBERING SYSTEM

Before CADD was an integral part of the A/E scene, computers were used by engineers mainly to perform structural analyses. These engineers typically kept their files on diskettes in their own possession or on the machine's hard drive. In the latter case, the files would be in a directory with the engineer's name or project name. This procedure was self-dependent. Engineer's files were as much their own as their calculation notepads.

Computer/file usage in the CADD environment has to differ from what has just been described. Drafting has now become a sort of

communal affair. CADD operators are given work on various drawings for several projects. All these drawing files must be available to all drafters. No longer can files be called STEVE1 or DAVID-P. Drawing files in the CADD age must be numbered so that they will clearly denote the name of the project, phase, and sheet number.

Coming up with a numbering system is not that difficult in itself. Making the numbering clear and concise is another matter, however. Considering that DOS allows eight characters, it is impossible to give out meaningful titles. Assigning a specific meaning to each character, such as A052M7QX (A = AT&T, 0 = design phase 0, 5 = fifth submission, etc.), will make for unpleasant and difficult deciphering. It is much easier to use a straightforward numbering system.

Numbering projects consecutively is a simple method, and it is easy to work with. For instance, if the first project on the CADD system is the Manhattan Bridge Rehabilitation Phase I, then, all computer drawings of it will have 1- for a prefix. The second project on the system is a new building for AT&T, Design Phase, which will have a prefix of 2-, etc. Therefore, the computer's directory will seem quite clear at a glance (see Figure 2-2):

 1-21 2-SSA
 1-S2 2-SSB
 1-S5 2-SSC

All files with the same prefix can thereby be easily recognized as belonging to a certain project. The numbers following the prefix should ideally match the Drawing Sheet number. This will vary from project to project. For unknown reasons, some architects or project managers choose to select long sheet labels such as S-DD-1205. In these cases, DOS systems cannot incorporate the full number. More concise numbering schemes remain the best alternative. If the 20th project on the CADD system is the rehabilitation of the Wilson Building, consecutive numbering still works:

 20-S1 (Project 20, Structural-Level 1 framing)
 20-S2 (Project 20, Structural-Level 2 framing)
 20-DET1 (Project 20, Detail Sheet 1)
 20-SEC1 (Project 20, Section Sheet 1)

```
Volume in drive C is C
Directory of  C:\DRAWINGS

  .                <DIR>        4-23-90   8:39a
  ..               <DIR>        4-23-90   8:39a
43-3F      DWG     132938       4-06-90  10:39a
43-FDN     DWG     479853       4-06-90   1:24p
43-PF      DWG     250290       4-06-90  11:08a
43-PR      DWG     105446       4-06-90  11:44a
45-TITLE   DWG      23297       6-27-89  10:29a
54-GR      BAK      20117       4-09-90  10:51a
54-GR      DWG      22327       4-09-90  10:51a
54-S7      BAK      37454       4-10-90   1:20p
54-S7      DWG      41560       4-10-90   1:24p
54-S7      PLT      74748       4-10-90   1:21p
54-S9      BAK      30223       4-10-90   4:03p
54-S9      DWG      39281       4-10-90   4:03p
54-S9      PLT      66832       4-10-90   3:36p
58-SK5     BAK     156284       4-17-90  12:54p
58-SK5     DWG     154536       4-17-90   1:18p
58-SK5     PLT     280676       4-17-90   1:22p
B-UPC      DWG       4738       2-05-90   1:11p
BEGIN      SCR         25       1-30-87   4:18p
EDIT       SCR          6       1-29-87   9:29a
       21 File(s)   13252608 bytes free

C:\DRAWINGS:
  .
```

Figure 2-2. With the suggested numbering system, it is easy to identify project drawing files.

The most important task regardless of the numbering system is for the CADD manager to keep an updated drawing coordination list available to all CADD users. Depending on how quickly new jobs and new sheets are added, the drawing coordination list should be updated either weekly or twice a week, and pinned to bulletin boards in central locations, or distributed to CADD workstations.

Do not underestimate the value of numbering and drawing coordination. Those who work outside the CADD room cannot fully understand the importance of having a workable system. Let us demonstrate what can happen when numbering is not strictly monitored.

Most professionals in A/E offices are very aware of and concerned with each project's progress. As soon as the firm begins work on a project, the rush is on. A set of drawings must be produced, but no one is sure how many total drawings will be needed, except that it will be at least 25. These sheets are numbered S101, S102, S103, etc. The CADD work begins on schedule and the computer numbers are selected. This is project 30, so drawing numbers will appear as the

following: 30-S101, 30-S102, etc. One of the project engineers decides to place a part-plan of the lobby between sheets S102 and S103, necessitating the old S103 to become the new S104, etc. Our project engineer neglects to tell anyone but the creator of the new S103, and there are two versions of 30-S103 in existence. A simple DOS copy command can erase one of them forever. Other problems can arise when an extra drawing is inserted into an existing set of drawings. When the drawing files are numbered with numbers that match the actual sheet numbers as shown above, the insertion of S103 necessitates the renumbering of all the drawings that come after S103. S104 now becomes S105, S105 becomes S106, etc. With manual drafting the drafter simply erased the title box and wrote in the new number. With computer files this task becomes somewhat more complex and potentially dangerous. One careful person should be assigned the task of renumbering the "original drawings," i.e., those on the floppy disk with standalone PCs or the ones within the file server for networked systems. Most problems occur when the new 30-S104 on the newly renamed disk and the old 30-S104 on the CADD drafter's hard drive do not correspond. Because the insertion of extra drawings into an existing set is unavoidable it is best to come up with a numbering system that relates more to what is on the sheet, rather than the sheet number itself. For instance, if S104 is Level 1 and S105 is Level 2, the computer files can be named 30-LEV1 and 30-LEV2. Then, when a Level 1 part plan is inserted between the two drawings, it can be called 30-LEV1A and renumbering the entire set of drawings files can be avoided. This change will be reflected on the Drawing/Disk File coordination list.

All CADD users should watch out for the types of changes mentioned above, and always check the current drawing coordination list before beginning work on a new drawing.

C. PITFALLS OF USING DIRECTORIES AS PROJECT SEPARATORS

There are a number of offices that follow the procedure started by engineers: using directories as project separators and organizers. Though this may be a workable solution in some cases, there are not enough safeguards against user errors for this to be an optimal solution. Because the directory, not the project name, is the identi-

fier, project names can be the same. If the first directory is AT&T and the second MANHBR, both may have drawing files numbered S1, S2, S3, S4, all the way to S20. If the incorrect directory is loaded with another project's diskettes, the result can be disastrous. Conceivably, the mistake might only be noticed when the eighth drawing in the AT&T series looks more like a detail of a cable re-anchoring than a structural plan of level 3 of an office building! (The floppy disks themselves would have the same name, with only a file or sticker to identify the job number.)

When all CADD drafters use the same directory, active project drawings become easily recognizable, and can be deleted periodically from the hard drive.

D. WHERE IS THE ORIGINAL?

It is easy to find the original drawing with manually drafted construction documents—just open the drawer within the flat files labeled with the project name. Unless the sheet is taped to the drafter's board, the flat files are the place to look.

With a computer generated drawing, the "original" drawing must be designated. A rule regarding where to find and store the original drawing should be established. In networked systems, the file server contains the latest version of drawings of active projects. These "original drawings" are accessed by users as needed, brought to their workstations for editing, and then returned to the file server when the work is finished.

For non-networked PCs ("sneaker nets"), the original should be kept on diskettes in clearly labeled diskette holders. The diskette version becomes the only official updated copy of any given drawing. Because each drawing may be worked on by several CADD drafters, for instance, by drafter A at workstation 2, then by drafter C at workstation 9, the hard drives of machines 2 and 9 contain different versions of the same drawing. Following procedure, however, each drafter updates the "official" diskette and returns it to the diskette holder. It is crucial that:

1. Diskette storage files are labeled for each project.
2. Each diskette is labeled and stores only one drawing.
3. The diskette is removed from its file only when it is to be

worked on. After work is done, the drawing on the diskette must be updated and replaced into the diskette file.
4. Another drafter not work on that particular drawing in error. Since it is "out of the library," currently being worked on, the original is kept at the workstation until work is done and the disk is updated.

E. RENAMING FOR INTERDEPARTMENTAL USE

When other departments (besides CADD) require a copy of a drawing file, the outside version has to be renamed. *Example:* Though the CADD department is working on drawing 20-S5 (fifth floor framing plan of project 20), one of the engineers needs to load the drawing onto her own computer for analysis and redesign. Thus, the copy of 20-S5 should be named 20E-S5, where the "E" represents "engineer's version." When the engineer, not being an expert CADD user, makes mistakes, or revisions for analysis, the original drawing file is safe in the CADD department.

II

The CADD department cannot function effectively without the creation of set procedures. While there are those who are nostalgic about the days of manual drafting, CADD is here to stay, and with it a series of procedures that should be followed carefully. These procedures are discussed in the remainder of this chapter.

A. SAFEGUARDING THE DRAWING FILE

Although the diskette is designated the "original drawing" and is kept safe in the labeled file, problems can arise. It is not uncommon for floppy disks to read errors. This problem can easily result in the loss of the drawing file. Because the value of each drawing is relatively high, representing many hours of work, steps must be taken to assure that at all times there is a second location where the drawing can be found. For standalone PC workstations this means that no one is to delete project drawings from the computer's hard drive until told to do so by the CADD manager. Therefore, when the original is lost or reads an error, the drawing can still be found and copied to a new diskette.

In networked systems, the file server contains the originals. A daily tape backup of all the files within the server assures that if a file is poisoned or the server goes down, the drawing can be retrieved from the tape backup.

Backing up works well as long as nothing goes wrong with the power lines or hardware, or program errors do not cause computers to freeze. To minimize any potential losses, work should be saved, as with the SAVE command in AutoCAD, every half hour. When the drawing is saved this way, the hard drive version is updated. If there is a short circuit, less than one-half hour's work is lost. CADD drafters working at machines that have been known to freeze up should save even more often.

B. SECOND BACKUPS

Even when a computer has an ample storage capacity, the drawing files tend to accumulate, taking up more and more bytes.

Eventually, the files must be deleted to make room for new work. Before the hard drive is cleaned up, the CADD manager should make a systemwide backup of all active projects. This systemwide backup should take place at least weekly. It is, in fact, best to designate a certain day for backing up drawings.

If CADD drafters are told that every Friday all projects are to be backed up on a second set of diskettes, they will then be free to clean old drawings off their computers on Monday.

This second set of project diskettes should be kept apart from the original set in the diskette library. The backup set becomes an effective emergency set and can be kept in a place such as a fire-resistant cabinet or safe (see Figures 2-3 and 2-4).

In networked systems, the file server and tape backup comprise the two copies of all drawings. Even file servers are cleaned up at times and projects may be removed. If this is done the tape becomes the only backup of all the work. It is therefore advisable for CADD drafters to save drawing files on floppy disks even though they will not be regarded as the "original drawings." The habit of first saving the drawing to a floppy disk and then sending it back to the file server assures that when the file server is cleaned up there are still two copies of each drawing.

In addition, when the network system goes down, it is easier to

35−S5.DWG

35−S5.DWG

35−S5.DWG

Figure 2-3 and 2-4. At all times there are two copies of a drawing file, the original and the backup copy.

access drawings on individual diskettes than to retrieve files from the tape backup.

Procedures only work when followed to the letter. Occasionally disregarding procedures makes the extra effort put into following them most of the time worthless. Reminders to new CADD drafters save everyone involved the pain of preliminary procedural mistakes. Memos can be useful as guidelines to procedures until they become second nature.

C. RECORD SETS

During the course of work on a project, periodic submissions are made to other consultants or to the client. It is usually submitted in hard copy (on paper/mylar) format. Whether or not diskettes are also submitted, it is advisable to keep a "record set" of the project (copy protected) as it was sent out. This drawing database record set can be useful for reference, in case there is a reversal in the design (changes made since the submission become invalid), or for legal purposes (see Chapter 9).

D. AUTOMATIC SAVING

It is possible to build into the CADD operation automatic backup procedures transparent to the user. For example, the system can be programmed to save the drawing in a different directory after a certain period of time elapses. This can assure that, if the working directory is disabled, or the diskette ruined, there is a copy of the drawing residing in a backup directory.

Another alternative is a custom "voluntary save command." In AutoCAD, the SAVE command on the menu can be written as a built-in macro (see Figure 2-5) that saves the drawing not only in the working directory but also in a backup directory set aside in case the working directory is deleted in error.

SUMMARY

Planning ahead can't be overlooked with CADD. While manual drafting had fewer restraints in terms of the degree of planning necessary, a few words which must be added to the titles of all of a

```
SAVE;;+
(SETQ BK (GETVAR "DWGNAME"));+
(SETQ DR "/BACKS/");+
(SETQ BAK (STRCAT DR BK));+
SAVE !BAK;+
Y
```

Figure 2-5. A menu routine for AutoCAD that saves a drawing in two separate directories in case of accidental deletion by the user.

project's drawings could be done painlessly "at the last minute" with manual drafting. Repeating that feat with an automated system, because the drawing has to be loaded onto a machine, changed, then saved, takes more time. Efficiency will be greatly improved with CADD, but much more so if a project's requirements are discussed at the start. Preliminary schemes which still might be used later should be kept, and others discarded. If the viability of these schemes is not discussed, they might all be deleted save the one version that was approved.

CADD drawings have to be numbered in clear and concise terms. Not doing so will create confusion. Identical prefixes, preferably numbers, should be given to all drawings of the same project. An updated drawing coordination list should be available for reference.

As discussed in Chapter 1, directories should be used conservatively. Drawings belong in a directory of their own, not in directories named after the project they belong to.

Storage systems must be regulated closely; a rule should be created as to where the original drawing will be stored. In networked systems, the file server contains the originals. In non-networked systems, disk storage files have to be labeled, and diskettes should be properly labeled, with only one drawing file per diskette.

Other areas where procedures have to be set up include user saving of the drawing, second backups, record sets of projects, and automatic saving of drawing files.

Chapter 3

Communication in the CADD Department

This chapter will discuss the transfer of project, drawing, and technical CADD-related information among CADD users.

Traditionally, in most engineering firms, work on production drawings was given out to various drafters through verbal instructions, hand-drawn sketches, or marked-up drawings. Each drafter then proceeded to work on the sheet he or she was given, making changes and additions manually, using their own style of drawing and lettering. It could be said that traditional drafters were "loners." Once given their portion of work, they sat on their stools and drew, using triangles, T-squares, and templates. The drafting table was a quiet, isolated place. The drafter did his work hunched over it, not really expecting or wishing anyone to look over his shoulder until his work was done.

With the growing popularity of CADD systems, these peaceful ways of drafting may be gone forever. Now departments must eschew their old habits and individuals must literally come out of the protective shells of their drafting tables. For reasons of efficiency, CADD operators must communicate with each other. The CADD system's full potential can only be realized if communication is on a fully functional level. In order to have an effective communication system, CADD drafters must work as a team; without good teamwork, the conversion to CADD may very well fail.

As a team, CADD drafters have to be more informed about an upcoming project. Because the CADD system is more complex than manual drafting, and its capabilities infinitely broader, the risk of

confusion and disaster is much greater, so it is essential that a CADD group receive orientation at the start of a new project.

The most desirable way to accomplish this is with a meeting between engineers, project managers, or architects, and the CADD-group. Items such as the general design concept, the scope of the job, and the expected number of drawings and their complexity can be discussed. Completion deadlines should also be mentioned.

The special requirements of the project (in what ways it deviates from normal standards and procedures) should be known from the beginning, not decided upon during production, when it will cause unnecessary delays. It may help if the CADD manager sets up a special training session to demonstrate any new or previously un-used techniques work on the project is likely to entail.

Because the CADD drafters assigned to one project often help out on other projects as deadlines near, it is best if all CADD drafters are up on most of the major projects in the office.

While an orientation meeting before work starts is ideal, many times the scope of the job changes while work is going on. Brief CADD room gatherings are sometimes all that is needed to commu-nicate significant modifications to the project.

Engineering professionals have to understand the importance of giving more detailed information to CADD drafters. At times, they will still drop off a marked-up sheet and say, "I need this by four o'clock." It is frequently up to the CADD drafter to "extract" what he has to know from the engineer/architect before starting work. When the CADD department operates various shifts, it is best to have one-half hour to one hour of overlapping time to allow for transfer of information, meetings, or just informal communication among the changing shift of CADD drafters. Without this opportu-nity to talk, project progress may be hampered.

Nevertheless, the question arises: How can a smooth and open line of communication among CADD users be assured?

There are a number of factors that can be manipulated to facili-tate open communication among CADD users:

A. The physical environment. The actual layout of workstations and plotters.

B. Word of mouth. Oral communication among users via CADD group meetings, and talking (even coffee breaks).

C. Documentation.

1. A brief file with vital information regarding each CADD drawing
2. Notes on the bulletin board
3. Frequently updated drawing and project lists (diskette corresponding to drawing #)
4. Diskette labels
5. A "hidden" layer on the CADD drawing itself containing drawing information

D. Special macros (custom commands). These return drawing information upon request.

E. Networks. Via messages left on the computer—"electronic mail".

A. THE PHYSICAL ENVIRONMENT

When first purchasing workstations or setting up a CADD department, the management may vary in their opinions of where the equipment should be placed or how they will be distributed within the office. The three viable options that exist are:

1. Dispersed Throughout the Office

In this scheme, workstations are distributed throughout the office, as drafting tables once were, usually near the project engineer in charge of the particular job the drafter will be working on. This option is the poorest choice when most of the drafting in the office is done by CADD drafters (even if the machines are networked). It makes CADD-group communication difficult, and is bound to lead to misunderstandings and inefficiency.

A distinction must be made at this point between CADD drafters and casual CADD use by engineers and architects. While CADD drafters within the CADD department are working at a CADD station full-time (eight hours and more per day), the engineers and architects involved are likely only to use CADD 10–30% of their time, as much time may be spent on coordination, meetings, and site visits. For these professionals, the computer becomes a design and analysis tool and is used mostly during the design development phase or initial layout phase of the project. For this reason, their

"personal" computers or part-time workstations are not assumed to be functional, full-time workstations and are best utilized when conveniently located and dispersed throughout the office.

Although CADD workstations dispersed through the office can be linked up via networks, communication among CADD drafters will still not be good enough. Features such as electronic mail cannot substitute for verbal or visual exchanges of information. Casual comments or questions that may lead to better understanding might never be stated to avoid lengthy explanations via electronic mail or a walk around the office (see Figure 3-1).

While network setups make it easy to send plots to the plotter without leaving the workstation, chances are the drafter will have to walk over to the plotter to insure that plotter default settings are correct, that the proper medium is loaded, and, if it is a pen plotter, to check if the pens are working. "Full automation" is thus not really attainable.

Finally, unless there is a full-time plotter operator, the drafter must retrieve his drawing when the plotting has been completed.

2. The CADD Room

The second option is to set aside an enclosed area or room designated as the CADD room. Within or near this room are located the workstations, each one with a reference table plus a table with the computer, monitor, printer, and digitizing tablet. Cramped areas, the sort of spaces that exist in engineering computer rooms, are not acceptable here since CADD drafters most likely work with large marked-up sheet sizes, 24 X 36 to 36 X 48 or 36 X 60 inches. Engineers work mainly with small calculation pads.

Individual direct lighting is important for viewing worksheets or paper drawings, charts, etc. (but directed away from the screen). Controlled lighting is very important for CADD drafters. In any situation where computer screens must constantly be scrutinized, too much brightness or glare can be distracting and even harmful to the eyes. An adjustable indirect lighting system is the best choice for an enclosed CADD area. Separate control for certain sections of the room are helpful. If a plotter is present, individuals near it may need a more intense level of lighting for filling pens, checking plotter settings or performing general plotter maintenance. It might be a

Figure 3-1. When the CADD workstations are dispersed throughout the office, communication among CADD drafters is hampered.

good idea to erect partitions around the plotter so that plotting activity and noise levels do not disturb CADD drafters nearby.

In addition to CADD drafting and plotting, other types of work may be going on in the CADD room. For instance, a drafting table for inspecting finished plots is essential. It is here that some of the finishing touches are added to plotted drawings. The table may also be utilized for trimming drawings, or simply for stacking them (see Figure 3-2 for a sample CADD room layout).

3. Clusters of Workstations

The third possibility is to set up clusters of workstations according to projects being worked on by the various CADD operators.

This solution has some of the advantages of No. 2, but also has some of the disadvantages of No. 1. While project information is easily shared among members of the cluster groups, each group may be somewhat isolated from the other groups. Thus, as projects are completed and new ones begun, regrouping or physical rearrange-

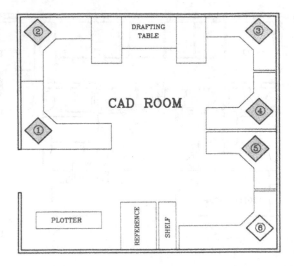

Figure 3-2. In the sample CADD Room layout, workstations are arranged for visual privacy.

ment of stations may become necessary. In addition, at times when there is a deadline to be met for one set of drawings, CADD drafters from other clusters may be needed on the job and would then be working apart from their original group (see Figure 3-3).

Problems with plotting will be similar to those found under arrangement No. 1, where travel to and from the plotter may be time consuming. Of course, any unnecessary movement about the office may end up distracting the drafters. They may stop and talk to friends, or they may be questioned by someone from another department. Going to the plotter may become a chore for these drafters, and the potential for lost time is great.

These rules are general; however, they apply to most mid-size architectural/engineering firms (assuming between five and twenty workstations). When an office is very small (three workstations) and office space is limited, communication is naturally facilitated and distances between CADD workstations are inevitably short. Centralization in a small office environment is unnecessary. Setting up CADD stations away from engineers and manual drafters still makes sense for some of the reasons mentioned earlier, such as different lighting needs. Conflicts may arise when engineers and manual drafters requiring abundant natural light allow window

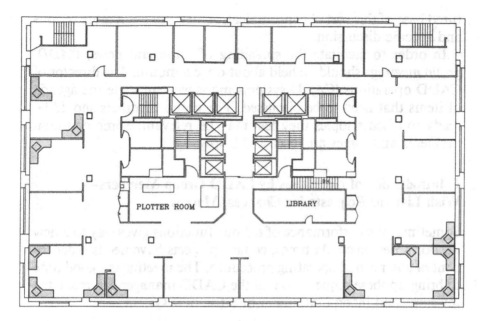

Figure 3-3. CADD clusters dispersed throughout the office facilitate CADD teamwork on projects.

shades to be open, contrary to computer operating needs of total shading.

In very large offices (over 20 workstations), the CADD department itself may be split up according to project or type of work being performed. It is also likely that more than one plotter will be used to serve the large number of workstations.

B. WORD OF MOUTH

Interior layout and planning can no doubt help or hinder CADD-group communication. When CADD workers are in close proximity to one another, talking or taking a look at what is going on at someone else's workstation is enabled. This form of communication is valuable. For example, if someone notices a format error on a particular drawing, he or she must let the other CADD workers know, so as to prevent future errors.

While these informal discussions do much to keep everyone in the CADD group on an open channel of communication, the unstruc-

tured base of this sort of communication necessitates a more serious and specific discussion.

In order to facilitate the spreading of important news, *CADD-group meetings* should be held about once a month. The director of CADD operations (CADD systems manager) can write the agenda of items that need to be discussed. The group members should be ready to discuss topics they feel may be relevant. Some common problems and topics are discussed below.

1. Introduction of New Ideas by CADD Group Members— Wish Lists or Requests for Changes/Macros

Sometimes the performance of tedious functions gives way to a new idea or a new need. At times, certain projects have needs independent of any normal operating procedure. The meeting is a good time to bring up these requests so that the CADD manager can make the revisions and incorporate them into the new system.

2. Sharing of Techniques/Gripes

Because CADD systems are so versatile, there are invariably many ways to accomplish the same goals. CADD operators do not have the same thought patterns. Each will approach problems differently. There are always those who make excellent CADD operators, while there are others who seem to just barely grasp what is going on.

By encouraging the sharing of techniques, or even mandating certain routines, the CADD group can examine openly the various methods employed and reason as to which is the most efficient. Thus, eliminating poor techniques and sharing more beneficial methods, the group as a whole can become more productive.

3. Software Updates and Other Changes

When it comes to changes, there are really just two types of people: those who are challenged by them, and those who despise them.

Unfortunately for the latter, software is constantly updated, and with each update come some exciting new capabilities (along with some bugs) and increased sophistication that will probably require learning more about the program. It is important to have the whole

system operate on the new software once one workstation has it, unless this workstation is used to test the update.

CADD meetings may involve a tutorial or demonstration of software updates. New enhancements added by the CADD manager should also be demonstrated to the CADD group as a whole. Key points about the new software can be made at meetings, and the CADD drafters will at least come away sharing a common body of knowledge about it.

4. Bugs — Software/Hardware Malfunctions

To computer users, the word *bug* is frightening, almost as much as the word *crash*. Bugs are common, though, and can even be found in the most sophisticated and widely used programs. The first and maybe most important step is recognition of a bug or malfunction. Once a bug is confirmed, it is wise to contact the distributors/writers of the program, who will probably suggest a "workaround" to avoid serious bug side effects. It is essential that the CADD group be aware of these workarounds.

5. Personality Conflicts

When a large-scale project is due for submission it is not uncommon to have most of the drafters help in making the final changes and plot the drawings. This effort is enhanced when members of the group involved work together, share information on progress of changes/additions, and coordinate the plotting of what can be a large number of sheets. After such a last-minute rush, the CADD drafters, having functioned as a team, have feelings of accomplishment. It is the sign of an effective CADD department when spontaneous teamwork occurs.

There are times when personal feelings of pride get in the way of good teamwork. As in any office situation, feelings must be handled with care in the case of CADD drafters. Because this is a transitional time between manual drafting and CADD, awkward situations can arise.

For instance, the 58-year-old senior drafter, once trained on CADD, could wind up being inferior to the 23-year-old just out of junior college who picks up CADD in no time. Resentment can

easily grow when junior shows senior that his techniques are ineffi-
cient, or that he is making careless errors.

On the other hand, the senior drafter may have no problem
accepting automated drafting, while the junior struggles with the
new system. In any case, the success of one may cause the other to
be jealous.

Even when seniority is not a factor, any team effort requires
cooperation and shared responsibilities. Personalities are therefore
an important consideration when a project team is to be selected.

CADD group meetings may wind up being group therapy ses-
sions; "I work much harder than her and produce twice as many
drawings . . ." or "She never shares her methods with the rest of
us." In these cases, the manager of the CADD department can and
should act as counselor to the group, trying to eliminate feelings of
malice through discussion and compromise.

C. DOCUMENTATION

1. Written

Even when effort is made to communicate all information verbally,
it is often necessary to have written files/instructions to assure that
everyone involved will be able to follow and remember procedures.

- The most basic types of information that must be written and
 distributed are project lists/drawing numbering and sys-
 tems/codes.
- Written (sometimes pictorial) information about block libraries
 or newly created blocks is essential so that all can use them.
- Reminders about new procedures can be distributed through
 memos.
- Large CADD departments can even have a monthly CADD
 newsletter to rate performance on various projects or preview
 upcoming departmental changes. A bulletin board in the
 CADD room is a good place to post news or procedures for
 CADD users.
- Simply writing basic information found on the diskette label is a
 good way to have a structured database (computer name, draw-

| 20-S5.DWG |
| Scale: 1/8"=1'-0" |
| |
| FIFTH FLOOR |
| FRAMING PLAN |
| [S-600.001] |

Figure 3-4. Properly labeled diskette.

ing scale, title/description, and drawing number, usually different from the computer name—see Figure 3-4).
- For complex jobs, a written file for each computer drawing will give anyone working on the project the basic information and specifications he will need.

2. Computerized

- When all else fails, drawing specifications must be placed on the drawing itself through a mark-up or hidden layer on each drawing. This layer is hidden because it will be shut off before a plot is made (see Figure 3-5).
- It is best to locate information on the same spot for each drawing (0,0 for example)
- Because of CADD's capabilities to work in extreme detail, whole paragraphs about the drawing can be stored in a tiny area that, even when plotted, shows up as a speck.
- Computerized messages (electronic mail) are another way to

```
┌─────────────────────────────────┐
│          INFO  VIEW             │
│                                 │
│   DWG  SCALE                    │
│   SHEET  SIZE                   │
│                                 │
│   SPECIAL  LAYERS               │
│   PLOT  AT                      │
│   HATCH  SCALES                 │
│                                 │
└─────────────────────────────────┘
```

Figure 3-5. Information can be placed directly on a drawing in a specified location on a hidden layer.

communicate. While effective in networked systems, in PC standalone workstations, electronic messages must be loaded one at a time, and may be self-defeating.

SUMMARY

Because successful CADD operations depend on teamwork, good communication among CADD drafters is essential. CADD-related information can be exchanged through memos, meetings, word of mouth, and computer messages. It therefore becomes vital to make the right decisions early on, and also to assure that everyone who is to be involved is aware of these choices, and of the reasoning behind the options selected. Information regarding project CADD standards, changes, revisions and deadlines, special layers, fonts or hatching, sharing of drawing blocks to save time, other time-saving CADD techniques, lineweights, as well as computer-related problems with hardware or software and error messages must be shared.

In order to facilitate communication in the CADD department, it is best if CADD equipment is concentrated in an enclosed area of its own: the CADD room. Dispersing workstations throughout the office results in misunderstandings and inefficiencies. Having clusters of workstations around the office has some of the advantages of the CADD-room setup, and some of the disadvantages of dispersing stations throughout the office.

Some common problems and topics that come up at CADD-

group meetings, which should be held once a month, include: intro-
duction of new ideas by CADD-group members; sharing of tech-
niques/gripes; software updates; bugs and malfunctions; and
personality conflicts.

In addition to verbal communication, which is facilitated by a
good setup of workstations, written communication is also impor-
tant. Keeping good written records and making notes for others (in
the form of memos) is beneficial to CADD department operations.

Chapter 4

CADD Drawing Standards

Drafting on a CADD system can actually be fun. A CADD drafter can use all sorts of colors and layers, etc. Layer names such as "Bathrm," "Sink," or "Door" may be assigned by CADD drafter A, while "Brm," "Snk," or "Dr" are meaningful to CADD drafter B. Beginning a CADD project this "fun" way will almost certainly lead to disaster. The CADD system provides a variety of colors and layers to serve a function. While the number of layers possible may be in the hundreds, it doesn't mean they all must be used. It is essential that layer names and designation (what elements belong on what layer) be decided upon before beginning CADD production work.

While CADD opens the door to nearly unlimited choices regarding format and presentation, these choices must be evaluated by the CADD manager with the coordination of the chief drafter. Only then can an office standard be established that will apply to all production drawings.

There is also a need to establish what the special requirements of each project are before beginning CADD production work. For example, if steel specifications for estimating takeoffs are necessary, the CADD drafters must use attributes from the start. Using attributes to label the steel on the structural framing plan or doors on an architectural plan enables easy creation of a file listing properties such as member sizes and weights, or door widths, fire ratings, hardware, etc. This file can be incorporated into a database program where it can be further manipulated and scrutinized.

Once format and standard decisions are made, they should be

followed by all CADD drafters. A sheet of standards or norms, explaining in detail the office format, should be posted near individual CADD workstations, where it will provide easy reference for the drafters (see Figure 4-1).

As with all rules, there may be exceptions in certain cases. Although deviations should not be encouraged, change in procedure may be necessary for atypical work, proposals, or presentations. Here again, it is important that the means of communication mentioned in Chapter 3 be utilized so that all concerned will know about any exceptions. Special procedures required for certain projects should be explained in memos or at meetings.

Those who have production experience may realize that an earlier format decision was not effective, and opt for a format revision.

Software updates and program changes may also necessitate some format revision. However, the more solid the original format setup is, the fewer the number of problems likely to crop up in the future.

A. LAYER ASSIGNMENTS—GROUPING OF ELEMENTS

In AutoCAD, grouping of elements can be achieved through layering. By layering a drawing, you are creating a condition whereby all entities on the same layer can be manipulated at one time. Thus, if all columns are on layer 7 then they can all be turned off (made invisible) or erased/changed as a group. It also generally means that all entities on the same layer have the same color, and thus can be plotted with the same pen thickness and line texture.

Besides the advantages listed above, layering can allow the architectural plan to be superimposed on the structural and mechanical plans to show inconsistencies.

The temptation may exist to place each type of drawing entity on its own layer. Remember, however, that more layers on a particular drawing create the need for more recordkeeping. In addition, the database becomes larger and the plotting procedures more complex. Use of layering to optimize production work while keeping important drawing entities separate is best.

In a structural office, entities such as columns, beams, text, centerlines, dimension lines, slab openings, and concrete walls should be grouped by layers (see Figures 4-2a–e).

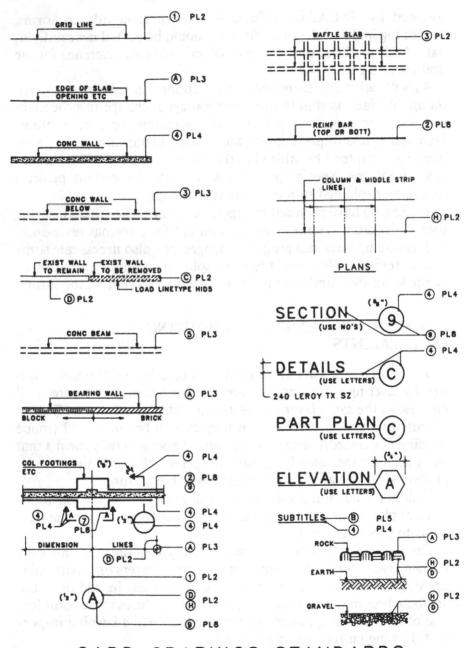

CADD GRAPHICS STANDARDS

Figure 4-1. CADD standards serve as guides for CADD drafters and assure proper placement of entities. Layers are indicated by encircled characters, and pen weights by PL#s.

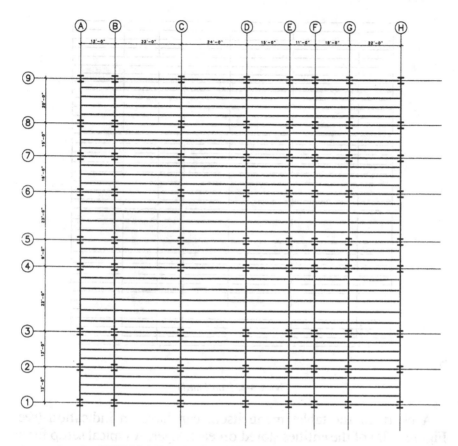

STRUCTURAL FRAMING PLAN

a

Figure 4-2. (a-e) Layering allows entities to be manipulated as a group. In this structural plan (a), entities such as beams (b), columns (c), centerlines (d), and dimensions (e), reside on their own layer.

The next decision involves layer naming. While descriptive names, such as COLUMNS for all columns, or BEAMS for all beams may at first seem a good idea, long layer names eventually become tedious when layer manipulation must be performed. The CADD drafter must then type out each layer name several times during an editing session.

Using a single-digit naming system for layers may seem hard to follow at first, but before long, all drafters involved should become so used to the system that it will be second nature.

b

Figure 4-2. (*continued*)

A chart, or the tablet menu itself, can have an indication (see Figure 4-3a) of the entities stored on each layer. A typical setup for a structural office is shown in Figure 4-3b. It is quite clear that layer 1 has a centerline type which is used for all centerlines on the drawing. Similarly, layer 8 is used for all text and labeling on the drawing. It is best when the tablet menu overlay is color coded for easy layer recognition.

Minimizing the number of layers on a drawing and making clear-cut decisions as to the placement of elements will eliminate hesitation on the part of CADD drafters, and will serve to enhance production.

Provisions should be made for cases where additional layers are needed. Layer names for extra layers should be simple and should follow a set procedure. If there are two types of concrete walls, one new and one existing, they both belong on layer 4. Because the existing wall will need to be manipulated alone, a new layer 41 is created. If there were other types of walls, 42 and 43 would follow.

The creation and setup of the initial standard layers is time

```
    I   I        I        I    I  I    I        I

    I   I        I        I    I  I    I        I

    I   I        I        I    I  I    I        I

    I   I        I        I    I  I    I        I

    I   I        I        I    I  I    I        I

    I   I        I        I    I  I    I        I

    I   I        I        I    I  I    I        I

    I   I        I        I    I  I    I        I

    I   I        I        I    I  I    I        I
c
```

Figure 4-2. (*continued*)

consuming and tedious. For this reason, it is best to have all standard layers, colors, and linetypes set up in the prototype drawing. This means that every time a new drawing is started, the standard layer setup will be incorporated.

Layers and their associated colors are very important to the CADD drafter. Because of the limitations on size of computer screens, it is usually hard to get a practical overall view of a drawing. In the overall view, the drawing elements are tiny. Color is one of the aids that CADD drafters use to distinguish between entities such as text and wall lines. For this reason (though AutoCAD allows for it), changing color of entities to colors other than those which have been assigned to them by layer is not advised.

B. SELECTING TEXT

As is true with most PC-based CADD systems, AutoCAD provides a variety of fonts from Greek to Roman. One of these standard fonts

d

Figure 4-2. (*continued*)

should be acceptable as the office standard lettering. If not, other fonts can be purchased or custom designed to suit office requirements.

While drafting lettering must be standard for all production drawings, title boxes and reports might require custom fonts to match other consultants' work.

C. BUILDING A SYMBOL LIBRARY

1. One of the advantages of CADD systems is the easy duplication of drawn features. Once drawn, the object or symbol can be inserted into any drawing with a simple command. Therefore, it makes sense to build up a library of these symbols for reference and later use.

Figure 4-2. (*continued*)

Though the symbols used in all structural offices are basically the same, they may be distinguished by the stylistic preferences of each firm. For instance, the North directional arrow is standard on all drawings, yet there are a number of possibilities for the mark (see Figure 4-4). Since these stylistic differences exist, the symbol library should be developed in house.

Once the most common symbols are drawn, they must be named and organized in a way that will allow easy access for all CADD users.

Naming the symbols with a prefix such as B- can make it clear

PEN WEIGHT	LAYER NAME	DRAWING ELEMENT
	(1)	CENTERLINES
PL2 (.25mm)	(D)	DIMENSION LINES EXTENSION LINES LEADER LINES TICS
	(H)	HATCHING SYMBOLS FOR EARTH GRAVEL,CONCRETE,ETC.
	(6)	COLUMN STRIP & MIDDLE STRIP LINES
	(5)	"X" LINES THAT INDICATE OPGS FACE OF BUILDING LINE
PL3 (.25mm)	(3)	CONC. WALL & BM ABV OR BELOW CONCRETE JOIST LINES WAFFLE SLAB LINES
	(8)	SMALL TEXT ARROWHEADS
	(A)	TOP OF SLAB SYMBOL STAIRS EXIST. STEEL COLS EXIST. STEEL BM
PL4 (.4mm)	(4)	EDGE OF SLAB SLAB OPENING CONC. COLS SLAB DIRECTION ARROWS SLAB OPNG LINES FOR SECTION MARK DIRECTION AND ELEV. MARK DIRECTION
PL5 (.5mm)	(B)	SUBTITLES MATCH LINE
PL6 (.5mm)	(7)	STEEL COLS ON PLAN LINES FOR STEEL BRACING ON PLAN
PL8 (.7mm)	(2)	REINFORCING STEEL STEEL BEAMS
	(9)	MAIN TITLES AND UNDERLINES COL. DESIGNATIONS INSIDE BUBBLES LARGE TEXT
	(0)	MARK-UP LAYER TO BE TURNED OFF WHEN PLOTTING
	(C)	EXTRA LAYER

a

Figure 4-3. (a, b) Chart (a) and tablet (b) indicate type of entities residing on each layer.

that any drawing with B- for a prefix is a drawing block symbol to be used by all drafters. Symbols can be stored individually in a separate directory or as a group in several drawing files.

If possible, the latter part of the symbol's name should indicate what the object is. B-NORTH would be the north directional arrow.

2. Even when the symbols are given "meaningful" titles, it would be nearly impossible for a CADD drafter to remember all the sym-

LAYERS / WORKING COMMANDS								
LAYER [GRID-L] ①	LAYER [BEAMS] ②	LAYER [WAFFL] ③	LAYER [SLAB] ④	LAYER [BLDG-L] ⑤	LAYER [PROP-L] ⑥	LAYER [COLUMN] ⑦	LAYER [TEXT] ⑧	LAYER [TITLE] ⑨
MARK-UP LAYER ⓪	LAYER "DIM" Ⓓ	LAYER Ⓓ	LAYER [STAIRS] Ⓐ	LAYER [SUBTITLE] Ⓑ	EXTRA LAYER Ⓒ	LAYER [HATCH] Ⓗ	LAYER OFF	LAYER ON
LAYER ?.	LAYER COLOR	LAYER LTYPE	"DIM" SELECT	POLYGON	POLY LINE	LAYER SET	LAYER FREEZE	LAYER THAW
PRPLOT	SOLID	HATCH	LINETYPE	FILLET	OSNAP SELECT	ELLIPSE	CHAMFER	CORNER FIX
PLOT	MEASURE	DIVIDE	DOUGHNUT ●	ARC	CIRCLE	DTEXT	TEXT	TEXT C

b

Figure 4-3. (*continued*)

bol names, and too time consuming to consult a list each time a symbol name is sought.

For the greatest efficiency, symbols should be placed on the tablet or icon menu as sketches (see Figure 4-5). When a symbol is needed, the drafter may select the box or icon with the illustration of the symbol.

Because symbols are always uniform in size—a ½″ circle should be ½″ regardless of the drawing scale—the menu must provide

Figure 4-4. Each firm has preferences regarding symbol style.

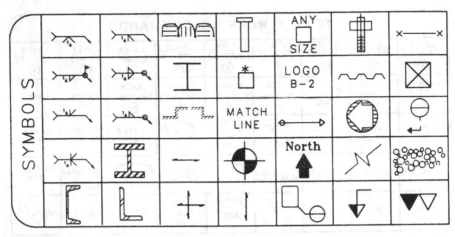

Figure 4-5. A pictorial representation of each symbol makes for the easiest way to access it.

automatic symbol scaling before insertion (see Figure 4-6). Say the original symbol, a ½″-diameter circle, was drawn with .5 units as its diameter in full scale. If the drawing is set up for ⅛″ = 1′0″ scale, indicating that 8 scale units equal one true inch, the circle's diameter must now read 4 units instead of .5, thus the circle must be inserted at eight times its original size.

As a symbol library grows, tablet icon "pages" can be added to the menu system.

D. USING ENTITIES OTHER THAN SYMBOLS

In addition to symbols, there are numerous elements of a drawing that are used repeatedly in structural architectural work. For instance: structural shapes such as wide flange sections, I-beams, angles and channels, and certain steel or concrete details that are typical in many types of construction.

Each time a W14 × 211 is needed, for example, a library selection

```
(SETQ O (GETVAR "CLAYER")) (SETQ SC (GETVAR "LTSCALE"));+
LAYER SET 7;;INSERT;*B-ROCK;\!SC;\LAYER SET !O;;
(SETQ O (GETVAR "CLAYER")) (SETQ SC (GETVAR "LTSCALE"));+
LAYER SET 7;;INSERT;*B-STUD;\!SC;\LAYER SET !O;;
(SETQ O (GETVAR "CLAYER")) (SETQ SC (GETVAR "LTSCALE"));+
LAYER SET 7;;INSERT;*B-NORTH;\!SC;\LAYER SET !O;;
(SETQ O (GETVAR "CLAYER")) (SETQ SC (GETVAR "LTSCALE"));+
LAYER SET 7;;INSERT;*B-SEC;\!SC;\LAYER SET !O;;
```

Figure 4-6. A menu macro that provides automatic symbol scaling.

or macro (see Chapter 6) can automatically produce this member. Similarly, typical details can save time when utilized in detailing projects.

Developing typical details, however, is a more ambitious project than developing symbol libraries, since it involves considerable time. Often, when things are slow in house, CADD drafters can be assigned to draw various typical details on the CADD system and develop a library disk file as well as a plot of the details.

When there is no time to develop a typical details library this way, details can be extracted as they are drawn for different CADD projects, and then organized into a details library.

Both structural shapes and typical details are available from commercial software vendors, but in-house libraries cater more specifically to each firm's special needs.

As with symbols, the structural shapes should be accessible via tablet or icon menus. The typical details, because they take up more bytes, should be stored on diskettes to be loaded into the computer as needed. A booklet with the detail name and a plot of the detail itself should be put together and made available to all CADD drafters.

SUMMARY

Before CADD drafters are ready to begin working, CADD drawing standards have to be decided upon. These standards should be decided upon by both the CADD manager and the chief drafter.

There are four basic "categories" in which standards have to be set: layer assignments, text fonts, symbol libraries, and typical details.

Deciding which entities will have their own layers, and what these layers will be called, are two choices that face the CADD department. Ideally, a limited number of layers should exist, with single-digit names for easy manipulation by CADD drafters.

A library of symbols that are commonly used on drawings should be built up. This library will consist of symbols in the firm's preferred style, named with a prefix denoting the type of symbol, and the rest denoting what the object is.

Typical details libraries can also be built, but as this is a more tedious task, it may have to be done piecemeal. As with symbols, these structural shapes should be available through tablet or icon menus.

Chapter 5

The CADD Department: The CADD Manager and Staff

Computerized drafting is simply a new and sophisticated tool designed to produce construction documents and design, or even presentation sketches. This new tool however, is quite complex. It can not be simply *used* in the same sense as a new drafting pencil or T-square can. This new drafting tool is a system, requiring a centralized form of management. Because of this inherent need, a new position is created, that of the CADD director/CADD systems manager.

The level of difficulty of managing a CADD system can vary depending on the sophistication of the CADD software, how it is used within the firm, and the size/scope of the CADD department.

The person selected to serve as CADD manager must be not only extremely versatile, but must have a good working knowledge of how the company as a whole operates, from CADD work to managerial aspects. There may be a problem finding someone with the proper qualifications for this job.

A. WHO SHOULD RUN THE CADD DEPARTMENT?

Since CADD use in the A/E environment is relatively new, the professional institutions are only now beginning to add CADD to their curriculum. Therefore, A/E professionals who graduated before 1980 may have little or no knowledge of computer-aided design or drafting, DOS, or programming.

Thus, the responsibilities of CADD director (systems manager) may have to be delegated to several individuals. For example, contributions may be needed from (1) the chief drafter, who has expertise in drafting, detailing, and production work; (2) a computer specialist, who is a hardware expert and can evaluate the various types of software on the market and put together the actual CADD network; as well as (3) the team head, a person with good organizational and managerial skills, well versed in AutoCAD software and programming (see Figure 5-1).

The third person, or CADD manager, is the one who will organize the CADD department, set up procedures, train CADD drafters and engineers, keep records, and customize the software.

This new addition to the structural/architectural office—the CADD department—needs effective leadership, otherwise it will not make very good progress. The CADD drafters cannot simply be set loose in the world of computerized production work. The amount of training and guidance required for CADD drafters exceeds that of manual drafting.

Because of the current shortage of individuals with expertise in CADD department management, it may be necessary to select a candidate from the office with a good professional background and a love of computers, and send her away for training in the specific

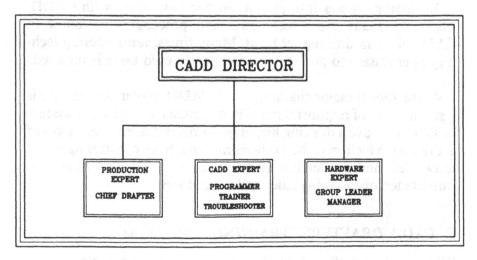

Figure 5-1. Qualities a good CADD Manager should have.

CADD system and its programming. Needless to say, the CADD department functioning will be directly related to the quality and effectiveness of CADD management.

B. SELECTION OF CADD DRAFTERS

The net product of both manual and CADD drafting is a set of drawings, but the means of production is significantly different. While fundamental knowledge of architectural or engineering working drawings must be present, there are other traits necessary for the CADD drafter.

1. The efficient use of computerized drafting requires intelligence and logic. With CADD, there are many ways of accomplishing the same task. It is best when the CADD drafters have the strategic thinking required to find the best means of accomplishing a task in CADD.

2. The drafter's personality and ability to work as part of a team are important. Because sharing of information and coordination are vital to the success of CADD-drawn projects, a reclusive-type person is not well suited for CADD work.

3. Memory comes into play when one is working with CADD. There are many more techniques and procedures to follow in CADD than in drafting by hand. Many times, remembering techniques necessary to perform less frequently used tasks is required.

4. The fourth major characteristic a CADD drafter should have is a strong sense of responsibility. When someone neglects a procedure or forgets to save a drawing file, major problems arise—even loss of a drawing which may be bothersome and time consuming to redraw. The new drafter has to be responsible and understand the importance of following rules and procedures.

C. CADD DRAFTERS' TRAINING PROGRAM

While sending drafters for training can teach them CADD, outside training is often too general, and does not emphasize the type of

work done by a particular office. In-house training is more beneficial since it can provide CADD training along with training in the set office procedures, and the customized software it is using.

A two-week period of training and practice is usually enough for the average trainee. At the end of the two-week period of instruction and practice, the newly trained CADD drafter should be ready for production work. It may then take an additional two to four months for the drafter to pick up speed and become a proficient CADD drafter, while experience and improvements in technique promote further excellence and efficiency.

CADD training and instruction should be individualized, that is, with the individual's background in mind. Some drafters with experience in other CADD systems may be ready to work in one week, while someone who never touched a computer before may need three weeks or more.

What follows is a sample training program, used to train WA (Weidlinger Associates) drafters in AutoCAD.

CADD TRAINING PROGRAM

I. Introduction and Basic Procedures
 1. Computer orientation—DOS basics
 2. Setup of AutoCAD directories
 • Our block library
 • The menu setup
 • Layer management

 3. Introduction to AutoCAD—overview
 • CADD as a drafting tool
 • Initial drawing setup
 a. Setting the scale
 b. Display controls
 Pan
 Views
 Zoom
 • Units/scale/limits
 • Basic concept of layers—layer setup
 • Relative/polar coordinates
 a. Using x,y

 b. Using @(length in feet)<(angle)
 c. Using @x,y
 d. Using screen pointing with the digitizer
II. Working Commands and Structural Library
 1. Drawing aids
 • Snap R
 • Ortho
 • Axis
 • Grid
 • Object Snap
 2. Drawing basics
 • Lines
 • Circles and arcs
 • Polylines
 • Solids
 • Points
 • Leaders
 • Doughnuts
 3. Inserting
 • Blocks—scale and rotation
 • Shapes
 • Text—size and styles
 4. Creating
 • Blocks within a drawing
 • Blocks as drawing files
 • Linetypes
 5. Automatic dimensioning
 • Setting dimensioning scale
 • Ticks/arrows
 • Efficient use of automatic dimensioning
 • Changing dimensioning setup
III. Editing Commands
 1. Importance of efficient editing with:
 • Fillet
 • Rotate
 • Scale
 • Erase
 • Move
 • Copy
 • Break

- Change
- Mirror
- Stretch
- Array
- Trim
- Explode
- Extend
- Offset

IV. Macros and Menu Use
 1. Use of tablet macros for drawing setup
 - Review of automatic drawing setup
 2. Efficiency through use of tablet menu
 - Insertion of symbols and structural members
 - Use of drawing and editing items
 - Use of screen menu
 - Use of submenus
 3. Utilizing macros
 - For structural layout
 - For automatic bridge generation
 - For structural sections and elevations
 - For truss generation
 4. Hatching
 - Use and insertion
 - Style selection

V. 3-D Capabilities
 1. User coordinate system—UCS
 2. Dynamic viewing—DVIEW
 3. Surface generation

VI. Saving Drawings/Active Jobs/Record Keeping
 1. Saving files on a disk—backup procedure
 2. Attributes
 3. DXF files
 - Writing a DXF file from an AutoCAD drawing
 - Creating an AutoCAD drawing from a DXF file
 - Creating a DXF file from a Lotus PIC file
 4. Record keeping
 - Layer information
 - Plot information
 - Pen thicknesses
 - Size and scale of drawing

VII. Plotting a Drawing
1. Using the Houston Instruments DMP 42
2. Using the Calcomp 1043
3. Pens/papers—use, storage, care
4. Printer plots
5. Creating a plot file—for sending out plots
VIII. General Review and Evaluation of Trainee
IX. Advanced Training (One Month CADD Experience Required)
1. Writing of customized menus
 • How to make changes in menu
 • Procedures following any change in standards
2. Design of linetypes
 • Linetype standards
 • Linetype scale settings
3. Customized shapes
4. Addition of hatch/font styles
5. Programming of macros
 • A review of macro usage
 • Efficient structural layouts with macros
 • Use of macros for charts
 • Macros for drawing setup and scale
 • Macros for graphs
 • Macros for generation of bridge elevations and plans
6. Using Edlin
 • Review of Edlin commands
 • Using Edlin to create and edit files for AutoCAD

D. TRAINING THE REST OF THE OFFICE

As CADD becomes more and more popular, offices will devote great amounts of space and money to the development of a state-of-the-art, fully operational CADD system, and a department that is more than capable of using computer-aided drafting efficiently and wisely.

The CADD department is therefore a prominent part of the machinery of the A/E office, and should be treated as such.

It should have a dynamic, involved relationship with the rest of the firm. The technological and organizational differences that au-

tomation has brought to drafting mean the whole system for producing drawings has evolved into a completely new and more powerful process.

Although the major work on CADD is performed by the CADD group (CADD drafters), other individuals will, almost inevitably, become involved (secondarily) in CADD production, and therefore must attain a certain degree of familiarity with the system.

1. **Top Management.** This is where the decisions are made about the company's future, and CADD management (usually countable on one hand) will invariably have to deal with company management when seeking to buy new computers or change a procedure.

It is best that management be kept in a position where it can feel the pulse of the CADD department at any given moment. Principals ought to know the system well enough to understand its capabilities. If an engineer is somehow dissatisfied with CADD performance on his project and complains to a principal, the principal's knowledge of CADD may help him decide whether or not the engineer's claims are justified.

At least one principal should maintain a close relationship with the CADD department head, so that there will not be an information gap between the two levels. CADD is now the means by which architects and engineers ply their trade, and that fact alone should be reason enough for the upper echelons to be concerned with it and follow its progress.

2. **Engineers.** Some engineers become fascinated by the CADD system and utilize it for preliminary design sketches, preliminary layout, or as a means to bridge the gap between analysis and drafting. When an engineer gives a hand-drawn sketch to a CADD drafter, it must be redrawn on the CADD system. If the engineer knows CADD, she can make a CADD sketch or layout, and the CADD drafter can then insert it into a drawing, perhaps only making minor modifications.

Engineers may also wish to familiarize themselves with CADD for their own needs. CADD is becoming increasingly integrated with the engineering field. This is due to the new capabilities of structural and other engineering design software to export or receive graphic data from CADD programs.

The benefits of this new capability are twofold. While graphics done in structural packages may be visually crude, exporting them to CADD offers the chance to spruce up a drawing in a short time, and then plot it for reports or presentations.

In the opposite case, receiving graphics from CADD can often save time when structural modeling would be time consuming within the structural design package but can be done rapidly from a model drawn on CADD.

Similarly, programs such as Lotus123 have the capability to export graphs to CADD. Once in the CADD system, the graphs can be further enhanced for presentation.

Other engineers may be involved in CADD only peripherally, by doling out work to the CADD drafters. In either case, some basic CADD orientation is essential.

A CADD orientation program for engineers lasting two days can work well. The most important function of the orientation is to point out the capabilities and limitations of the CADD system, and how much it differs from manual drafting. If engineers continue procedures from the old days, the full potential of CADD will never be realized. What follows is a sample training program for engineers, used at WA to orient engineers with AutoCAD.

CADD ORIENTATION PROGRAM

For Engineers and Project Managers

I. Introduction to AutoCAD
 1. An Overview of AutoCAD file management
 a. Support files
 b. Custom menus
 c. LISP files
 d. Library of shapes and symbols/slide files
 2. Basic drawing setup—the menu/AutoCAD—Our System
 a. Use of the menu and submenus, pull-down menus and icons
 b. Setup macro for new drawings
 c. Drawing scale and sheet size

 d. Layer management
 e. Office standards and procedures
 3. Common working commands
 a. Brief review of available drawing commands
II. Changing a Drawing File
 1. Editing commands
 a. Introduction to various editing commands
 b. Time consuming changes
 c. Efficient editing
 d. How flow of information affects productivity
 e. Importing ASCII files—rules and limitations
 2. Relationship between CADD drawings and hand drawings
 a. Changes and checkprints
 b. Alternative ways of checking a drawing file
 c. Efficient operating procedures in crisis situations
 3. Hands-on basics for engineers
 a. Entering an AutoCAD drawing
 b. Display controls/zoom, pan, view
 c. Information access/shell, dist, list, status
 d. Exiting the drawing
III. Advantages of Shape and Symbol Library
 1. Saving time with blocks
 a. Block management
 b. Slides for viewing the library
 2. Attributes and their usefulness
 3. Easy access to blocks and symbols
 a. Block access via the menu
 b. Insertion/scale selection
IV. Utilizing Macros
 1. Quick drawing layout/the grid macro
 2. Drawing details and sections
 3. Defining nodes
 4. Importing related software files to AutoCAD
 5. Quick graph generation
 6. Drawing trusses and bridge elevations
 7. Various 3-D shapes and views
 8. Macro development for specific projects
V. Plotting

 1. Types of drawing plots available—what each involves
 2. Drawing media—plotting procedures
 3. Time requirements
 VI. Communicating with Clients and Subconsultants
 1. Exchange of data files
 2. Using translators

 3. Architects. Engineering firms often use drafters to do production work while the engineers themselves stay with design analysis and preliminary sketching. Architectural firms, however, often have a project architect who does the major design work while other architects or junior architects do the layout or drafting. In this type of arrangement, the architectural professional doing his or her design/drafting on the CADD system should be fully trained on CADD as a CADD drafter, and follow the procedures set up for the CADD department. Although the degree of professionalism in this case differs from that of pure drafters who often have less in the way of higher education, the departmental problems and qualifications of the individuals desired are similar.

 The main design architects should have a two-day orientation to the CADD system in place in order to know at least what can be expected from CADD.

 4. Project Managers. While project managers rarely have hands-on experience with CADD, or rarely deal with CADD drafters, it is equally important that they become familiar with the system.

 Projected costs, time, and expectations will be more realistic if project managers receive CADD orientation.

 5. Marketing. The marketing department, responsible for, among other things, winning jobs for the firm, must present an appetizing picture of the firm to possible clients. This should involve touting the CADD capabilities of the company, if and when they are developed enough that CADD is employed in at least half of the firm's jobs. A list of computer hardware may be maintained, and in this case the CADD manager must keep the marketing department current on hardware upgrades.

 The two departments may also collaborate on a feature story or a series of updates on CADD for the company newsletter. With cover-

age of this kind, both office employees and past and future clients can keep up to date about the developments in CADD.

A story about a specific project done on CADD, or a story about new CADD software and hardware, is appropriate for unlimited distribution. Other articles introducing new employees, etc. can be printed in an insert to be distributed only within the office.

The CADD department can, with the help of the marketing department, gain more exposure both to outside professionals and within the office.

6. Secretaries. There is a considerable amount of third-party software available which will interact with CADD. For instance, CADD drafters no longer have to write lengthy notes on the drawings, or even write schedules. This can be done more efficiently if typed up by a secretary on any word processor, then imported into the CADD drawing. In order for this operation to work, the secretaries must know which methods to employ and which to avoid.

For example, it is best to import ASCII files without use of control characters and in nondocument format. With experience, the secretary will know what to do.

When a desktop publishing program such as Ventura or Quark-Express is used, it is even more important for the secretaries to have familiarity with the company's CADD system. It is often desirable to merge two files (CADD and DTP) to form proposals or reports.

7. Others. Inevitably, many other people in the office become interested in the in-house CADD system, and try to play with it during lunch hour, or after hours. It is important to cut down on those who are just playing, and make rules with reference to practice. This will assure that an inexperienced employee will not wipe out directories or make changes to the CADD configuration.

E. INFORMATION MANAGEMENT—GIVING WORK TO THE CADD DEPARTMENT

All work given to CADD drafters must pass through certain channels. Without strict controls, drawings done with CADD could be misplaced, forgotten, or lost in a sea of computer drawings. Engi-

neers often approach CADD drafters with sketches, claiming, "This is a rush job" and that there will be five sketches 24" × 36", etc.

The drafter may never be told about the project, its scope, or the drawing numbers. It then becomes the task of the CADD department to categorize the job and put it on a list in a way that it will be easy to find in case there are references to the drawings, or if work has to be done on them in the future.

It is best when everyone working in conjunction with the CADD department knows the importance of following this tracking procedure. If a CADD drafter is asked, "Remember those sketches you did for Steve last month? I need to use them for the production stage of the project," he will not likely remember the project or the drawing names without the aid of a coordination list.

As with books in a library, it is of little use to know that the information (book) exists if you do not know how to access that information.

With CADD, recordkeeping can be an added bonus when details of completed drawings can be utilized in new jobs with similar parameters.

While today's problem may be how to utilize CADD and organize a CADD department, tomorrow's problem will be one of information management (of electronic data). Since buildings/bridges have many common denominators, it will be useful a few years down the road to find a brick wall section for another project very similar in nature. The question becomes, "What is the best way to organize past computer drawing files for future reference?" (See Chapter 10.)

The hard copies/microfiche can be accessed and perused for reference, but the electronic data itself can often be reused with minor changes. As the years go by, hardware configurations and software versions will inevitably progress, making some older drawing files obsolete. The possibility of converting or updating older drawings to keep up with the latest CADD system in use may exist.

SUMMARY

CADD as a system is so different from the manual drafting that old managerial and staffing standards will have to be radically revised in converting.

The position of CADD director/manager will have to be created.

This person will have to be knowledgeable in several areas. There might have to be more than one person to comprise CADD department head. This team's skills combined are what the position requires. The first is the chief drafter, the second a computer specialist, and the third the team head. If all these skills can be found in one person, then there should be no doubt as to his/her acceptability as CADD manager.

Drafters also should have certain characteristics. CADD drafters have to be intelligent, logical, and good team players. They must have good memories, and be responsible and dedicated to their work, which is less "personal" than manual drafting was.

These drafters must be trained, ideally over a two-week period, with each particular drafter's professional background in mind.

Others in the office, such as engineers, architects, project managers, and secretaries, have to be familiar with CADD, and know what to expect from it and how to do their work with the system in mind. Top management and marketing personnel should also know the basic capabilities and limitations the CADD system has.

Information management requires the attention of all drafters, and the coordination skills of the CADD manager. In order for parts of drawings to be imported in similar new drawings, these old drawing files must be accessible.

Chapter 6

You Can Finally Begin

Once the system and procedures to be followed are decided upon and organized, work on the CADD system can finally begin.

There is one last important decision to be made, however: whether to use a standard menu system (sometimes provided by the CADD software), or to purchase or create a customized menu and macro system. Most systems can be customized to an extent. With AutoCAD, a great freedom or "open architecture" is provided, and customization can be accomplished easily.

There are two prerequisites to investing in a customized system. The first is that the firm's needs be evaluated. This may sound simple, but it often takes some time before the system requirements can be recognized. Frequently, the type of project being worked on dictates what is needed of the CADD system. Feedback from CADD drafters and architects/engineers helps the system requirements evolve. Past experience is also a good base for establishing requirements. Words such as "I don't want us ever to have to do it this way again . . ." can set firm certain desired characteristics of a CADD menu system. Also, remember that even when a customized system is in place, it might occasionally need updating, bug eradication, and other adjustments.

The second prerequisite is deciding upon the means of attaining the most suitable customized menu program. The best option would be a system developed in-house to suit the firm's operations. This is often not a possibility because there may not be anyone employed by the firm who is capable of programming and is knowledgeable in computer languages (such as LISP and C) and AutoCAD, or whatever CADD system is used.

An outside consultant can be hired to mold the CADD system to

suit the company's needs. This may be somewhat costly, though, and both methods can be time consuming, delaying the start of full production work.

Finally, a search for third-party products on the market may be necessary. There are now a number of menu systems designed especially for structural/mechanical/civil engineering or architecture, complete with macros and a library of symbols and elements. Third-party software can be used as a base which can then be altered further until acceptable by the company.

Whatever the case, it is best to start out with the right system. Once the CADD group gets accustomed to a certain menu system, they will be reluctant to change. This is even true of hardware setups, such as mouse versus keyboard or digitizer. Habits are hard to break even if the new method is easier and more efficient. After investing much time in learning one system, most will want to stick with it. Suggestions for change will probably come from management, i.e., people who are not using the current system.

A. WHAT TO LOOK FOR IN A MENU SYSTEM

It is true that every type of firm requires different features of a menu system. There are some basic necessities, however, that are common to all A/E firms.

1. Automatic units/scale/sheet size setup: CADD drafters do not have to agonize when trying to set up a CADD drawing with a scale or sheet size that is not on the automatic setup menu. Such waste of time can be avoided when setup menus include common architectural and engineering scales as well as metrics.

2. The menu system intended for the office should be evaluated by the department head as well as some experienced CADD drafters. Only the CADD drafters have a true feel of what commands they employ most often, and the kind of operations that should be automated.

Some menu systems offer too many options. For instance, in AutoCAD (see Figure 6-1), every time editing is required, EDIT must be selected, then the ERASE command, with an additional

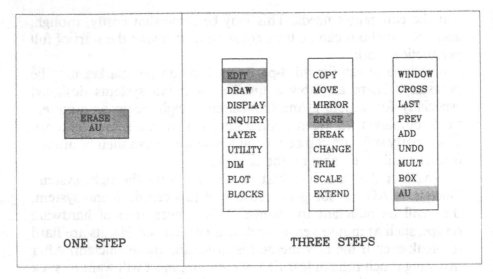

ONE STEP	THREE STEPS

Figure 6-1. One-step "erase" operation vs. three-step operation.

selection of W, C, BOX, or AU before the command is activated. Instead, ERASE AU can accomplish all that in one step.

Tablet menus are often too busy; they may be cluttered with multiple small boxes containing commands which are rarely used. The tablet should be organized in a way that makes the most frequently used commands easiest to access (see Figure 6-2), and the less commonly used ones more remote (far side of the tablet or on pull-downs or screen submenus).

It is not a bad idea to omit very rarely used commands; if used only once a week, they can easily be typed in through the keyboard.

3. The menu system should contain a symbol library that is relevant to the profession. For instance, a detailing shop may need all weld symbols, whereas an architectural office would require plumbing symbols (sink, toilet, tub, etc.).

If an extensive library of details is needed, it can probably be purchased and then modified to suit the user's purpose, and added to the menu.

4. Lastly, important to any high quality menu system are parametric features. With CADD, objects should only be drawn once.

WEIDLINGER ASSOCIATES MENU SYSTEM

LAYERS / WORKING COMMANDS

EDITING

LAYER CENTR-L ①	LAYER BEAMS ②	LAYER HID-L ③	LAYER SLAB ④	LAYER DASH-L ⑤	LAYER PHANT-L ⑥	LAYER "SHAPES" ⑦	LAYER "TEXT" ⑧	LAYER "TEXT-LG" ⑨	135	90	45
MARK-UP LAYER ⓪	LAYER "DIM" ⓓ	LAYER ⓓ	LAYER Ⓐ	LAYER Ⓑ	LAYER Ⓒ	LAYER Ⓗ	LAYER OFF	LAYER ON	180 ← 0 → 360		
LAYER ?*	LAYER COLOR	LAYER LTYPE	"DIM" SELECT	POLYGON	POLY LINE	LAYER SET	LAYER FREEZE	LAYER THAW	225	270	315
PRPLOT	SOLID	HATCH	LINETYPE	FILLET	OSNAP SELECT	ELLIPSE	CHAMFER	CORNER FIX	REDO	ROTATE	SCALE
PLOT	MEASURE	DIVIDE	DOUGHNUT	ARC	CIRCLE	DTEXT	TEXT	TEXT C	UNDO	U	SNAP R

MACROS

SELECT WF	SELECT COLUMNS	DETAILS & SYMBOLS	CANCEL			OOPS	ERASE BOX	ERASE
SHELL	SELECT ANGLES & CHANNELS	3D COMMANDS	BEAM TEXT			MOVE	MOVE BOX	COPY
TEXT IN	TRUSSES	WALLS	RECTANGL			BREAK F	BREAK	BOX
FRACT. ⑤	FRACT. Ⓒ	SETVAR DISPLAY	GUIDE LINE			CHANGE TEXT	CHANGE	PAN
END	DIM HOR	DIM VERT	SAVE			ZOOM ALL	ZOOM E	ZOOM P

SCREEN MENU AREA

GRID LINES FIRST DIR.	GRID LINES SECOND DIR.	BB1&1	BB1&1		Y	R	L	M	C	@	<	REDRAW	DIST	MIRROR
COLUMNS	BEAMS IN FIRST DIR.	BEAMS IN SECOND DIR.	MACRO STRINGERS			USER B-1		ANY SIZE	COMPANY LOGO B-2			INSERT	PEDIT	LIST
GRAPHS	DEFINE POINTS CALCULATE	CREATE STEEL MEMBERS	SINGLE BAY WAFFLE SL OR STRINGERS				MATCH LINE			MULTIPLE INSERTS		STRETCH BOX	ARRAY	TRIM

HATCH/SYMBOLS

| | | | |
| EXPLODE | EXTEND | OFFSET |

Figure 6-2. The WAMS Menu System is an example of a structural tablet menu.

When identical, an object can be reused. Even when an object has different specifications (dimensions) than what is needed, parametrics make reuse possible. A parametric program is intelligent software that knows, for instance, that a steel wide flange section has a web of flanges and a fillet at their intersection. The program asks the user to input section width and depth, web thickness, flange thickness, and radius of the fillet, allowing for the proper "construction" of the section. Macros are best when they are custom designed.

There are, however, similarities among like firms in their parametric needs.

For example, all structural framing plans contain centerlines to indicate column-grid intersections. Framing plans also contain columns, girders and stringers, dimensions, etc. Therefore, it is safe to say that a macro that automatically lays out centerlines, columns, beams, bubbles, and dimensions is useful for all structural engineering firms.

Simply having macros within the menu system itself is not enough. The macros also must be user friendly—simple and straightforward. When macros are too elaborate or require too much user input, the drafter might as well just draw without them. In fact, when a macro is too complex to use or offers too many choices, the CADD drafter may bypass it.

A good example of a simple macro is the generation of a truss cross-section (see Figure 6-3). The prompts:

Give truss depth

Give panel width and number of panels

are all that are required to be answered by the user. All that remains is selection of a location on the screen where it is to be drawn.

Another example is the automatic generation of a structural framing plan (see Figure 6-4). Once the basic rectangular framing is

TRUSSES

Select:HOWE..WARREN..PRATT
Give Depth:
Give Panel Width:
Give Number of Panels:

Figure 6-3. After responding to the prompts, the selected type of truss is generated parametrically.

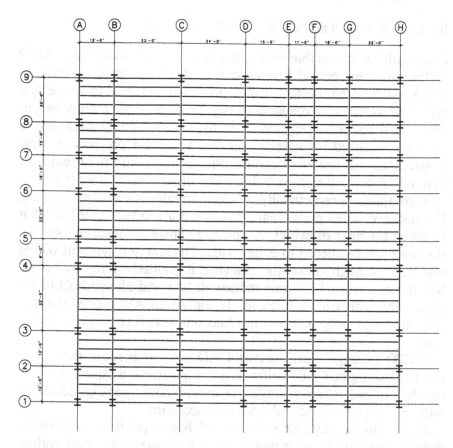

STRUCTURAL FRAMING PLAN

Figure 6-4. After responding to the prompts which demand number of spans, span spacing, and column size, this type of framing plan is generated.

drawn, editing can be performed to have the plan comply with a particular layout (openings can be placed, etc.).

Time spent on getting the right menu system in place is not wasted, for a solid menu system is yet another key to a successful CADD department.

The menu system really becomes *the* tool by which drawings are developed. It can be an enhancement or an impediment to the CADD operations, depending on how well the company has chosen.

B. AFTER CHOOSING A MENU SYSTEM

Even with an acceptable menu, because it is dynamic, the CADD system will need periodic reevaluation which will bring on changes and updates. Also, because every project is different in scope and type, the menu may demand changes, or alternate menus be put into use for special projects. It is up to the CADD manager to evaluate the need for special macros for certain projects. A large project that will require a certain type of procedure may require a macro to automate that procedure. The process may be quite simple to accomplish parametrically, while manually it could take hours. For instance, when preliminary layout is done in 1/16" scale but 1/4" is required for final drawings, AutoCAD allows for rescaling so that the work will be correct in either scale. The text and symbols will be too large, though, once the drawing is plotted at the 1/4" scale. Macros written in LISP can reduce all text and all symbols to the given size with one command. Using AutoCAD alone, the size reduction can only be accomplished one text line or symbol at a time.

CADD packages such as AutoCAD are much more than mere drafting packages. CADD offers many sophisticated capabilities that can be utilized either through the main CADD package alone, or with the help of outside (third-party) software.

The key to the utilization of many of these capabilities lies in early decision-making. In other words, the project manager, chief drafter, and CADD department manager should meet to discuss the project's requirements in addition to production drawings.

For instance, material takeoffs are easy, and are allowed for in AutoCAD; however, if the proper information is not input by CADD drafters from the start, these takeoffs will be incomplete or will waste much time (if drafters have to reinput information or redo work another way). Similarly, if a complex framing plan or connection needs to be viewed in perspective, as well as in plan, section, and elevation, drawing it solely in 3-D from the onset will yield all the views, and any viewpoint/angle in 3-D.

If a file listing all column locations would come in handy, provisions can be made at the beginning that make this data takeoff very simple. Even a basic decision such as placing these on a separate layer can make data extraction less painful. Area calculations, beam

sizes, number and types of plumbing fixtures, or lighting types can often be extracted from CADD drawings.

Even graphic solutions to engineering problems become easier and significantly more accurate than when solved with manual sketches. With computer graphics, an accurately drawn detail (by the CADD drafter) can be utilized as an aid to a calculation done by the engineer.

SUMMARY

What stands in the way of sophisticated use of CADD systems for purposes other than drafting is lack of foresight. Careful planning can allow CADD to be used to its full potential. The sooner A/E firms realize this, the sooner they will be able to optimize CADD.

Purchasing the right menu system will allow CADD department drafters to save time. The menu should effectively make automatic procedures which had been bothersome and slow in the past.

Macros, or parametrics, will draw certain entities and details after asking the user for specifications, also saving much time. A whole range of tasks can be accomplished with macros, from the generation of a detail to the generation of a structural framing plan. Again, choosing the menus and macros suited to your needs is the first step in the direction of greater efficiency. Cumbersome macros will, over time, be ignored by drafters. The best menu/macro system is one that drafters like using.

Chapter 7

A Brief Guide to AutoCAD for Managers

AutoCAD is the most widely used PC-based CADD software. Similar to other high quality CADD programs, AutoCAD is designed with a great many capabilities and can be utilized by a wide range of firms, from structural and architectural design to industrial. Though a great variety of capabilities are available, they may be used selectively or customized for a specific purpose. It is this flexibility that makes AutoCAD such a favorite in PC-based CADD software among A/E firms.

A. WHAT YOU HAVE TO UNDERSTAND ABOUT AutoCAD BEFORE BEGINNING

The aforementioned range of possibilities that are to be found in AutoCAD have to be narrowed to several features that everyone involved in CADD work should understand. From this basic understanding of the most important features comes the ability to make wise CADD-related decisions in the future.

An example of one essential is knowing how to set up the scale or sheet size of a drawing without the aid of macros or automatic drawing setup features on menu systems (see below). While automatic setups are helpful, and should definitely be employed, the CADD drafters have to be able to perform this operation unaided. Without this basic knowledge, the drafter will be puzzled when an unusual drawing scale requires manual setup.

There are other basic concepts that must be grasped by CADD users for optimum results. The following are the most fundamental

AutoCAD concepts that require comprehension. The basics, however, are similar throughout most PC-based CADD systems.

1. Drawing Scale and Sheet Size

The ability to set up a computer drawing "scale" and "sheet size" manually is important. A thorough understanding of this concept will enable drafters to manipulate drawing scales and measure distances on the screen in real inches instead of scale inches. For instance, if someone wishes to represent an object measuring 20' × 30' on a piece of paper 24" × 36", the scale would have to be 1" = 1'0" in order for the object to fit on that sheet. This task was no problem with manual drafting; all that had to be done was to pick up the 1" = 1'0" scale and start drawing.

On a computer screen, however, you must allot space to draw a 20' × 30' object. This can be done by setting the drawing limits (the LIMIT command). The default sheet size in AutoCAD is 9" × 12", i.e., lower limits are 0,0 and upper limits 12, 9. Working in full scale, an upper limit of 36', 24' (see Figure 7-1) will allow the user to have the necessary coordinate units within the sheet's limits, to fit the desired object in.

If the size of the object is doubled to 40' × 60', the object no longer fits on a 24" × 36" sheet of paper in full scale. Therefore, the drawing scale must be reduced for it to fit on a 24" × 36" sheet. Thus ½" = 1'0" scale can be used, which is the equivalent of two drawing units per real inch, and the upper limits can be set at 72, 48 [2 × 36" and 2 × 24"] (see Figure 7-2).

2. Units versus Real Inches

There are several unit types that AutoCAD allows:

Scientific	1.55E + 01
Decimal	15.5
Engineering	1' 3.50"
Architectural	1' 3½"
Fractional	15½"

Figure 7-1. Setting upper limits will allow user to have necessary coordinate units within the sheet's limits.

Regardless of which unit type is selected, the user must know the relationship between drawing in scale and measuring in real inches.

A report written on an 8½″ × 11″ sheet of paper, with ¹⁄₁₀″ high lettering can be done on a one-to-one basis: 1″ = 1″, with lettering height = .1 (or ¹⁄₁₀″). Most often, however, architects work in scale.

Figure 7-2. Resetting limits to allow for larger objects.

In $\frac{1}{8}'' = 1'0''$, a typical framing plan scale, drawing measurements are taken using the coordinates. For symbols and text, the conversion from drawing units to real inches becomes necessary. In this particular case, 8 feet in drawing units = 1 real inch, therefore, in order to get $\frac{1}{10}''$-high lettering, the text height in drawing units must be equal to .8 or $\frac{1}{10}$ of 8 feet (see Figure 7-3). If the plan is drawn in $\frac{1}{8}'' = 1'0''$ scale, and is now desired in $\frac{1}{4}'' = 1'0''$ scale, only the upper limits of the sheet have to be reset. The scale drawing is then transformed to the $\frac{1}{4}''$ scale. The text and symbols on the drawing, however, must be reduced in size in order to still $= \frac{1}{10}''$ when plotted. The letter height must now be .4 units or $\frac{1}{10}$ of 4.

Even with a good understanding of these basic concepts, it is best to have a text and symbols chart posted in the CADD room for quick reference. It is also useful to have scale conversion rules posted (see Figure 7-4).

3. Know Your Way Around the Sheet

Various methods of measuring distances are shown in Figure 7-5.

4. Use Layers Wisely

Utilize layers to separate various entities, and types of entities only as they need to be divided and manipulated as a group. Use the LAYER ON and OFF, FREEZE and THAW, color, and linetype to enhance the drawing organization (see Figure 4-2 in Chapter 4).

5. Methods of Object Selection

There are several to choose from:

• Single—select each object by pointing to it

TEXT HEIGHT

1" = 8 units thus

.8 units = 1/10"

Figure 7-3. Setting text height.

SCALES

PROCEDURE TO CONVERT A DRAWING FROM ONE SCALE TO ANOTHER

1.) Use the "dwg—set" to reset the existing drawing to the desired scale.

2.) The drawing is now at the new scale, however, you must rescale all text, arrowheads, titleblocks, ticks etc. Use the macros in the "chg—chk" sub—menu to rescale these entities. When the macros can not be utilized, use the "scale" command to rescale these entities.

RULES FOR CONVERTING TITLEBLOCKS FROM ONE SCALE TO ANOTHER

When inserting a title block or a symbol into a drawing the rule is:

DIVIDE THE OLD SCALE INTO THE NEW SCALE

EXAMPLE: 1=4 is old scale
1=8 is new scale

CONVERSION FACTOR: 8/4 = 2

EXAMPLE 2: 1=20 is old scale
1=16 is new scale

CONVERSION FACTOR: 16/20 = .8

a

Figure 7-4. (a–e) Setting rules and posting charts for symbol and text scale conversions is always helpful.

TEXT SIZE CHART

SCALE	M 1=10	M 1=25	M 1=100	M 1=200	M 1=250		1=60	1=50	1=40	1=30	1=20	1=10	LEROY SIZE
	.02	.05	.2	.4	.5		4.8	4	3.2	2.4	1.6	.8	80
	.025	.0635	.25	.5	.635		6	5	4	3	2	1	100
	.03	.076	.30	.6	.76		7.2	6	4.8	3.6	2.4	1.2	120
UNITS	.0355	.089	.355	.71	.89		8.4	7	5.6	4.2	2.8	1.4	140
	.044	.11	.44	.88	1.1		10.5	8.75	7	5.25	3.5	1.75	175
	.0508	.127	.508	1.016	1.27		12	10	8	6	4	2	200
	.061	.152	.61	1.22	1.52		14.4	12	9.6	7.2	4.8	2.4	240
	.0737	.184	.737	1.474	1.84		17.4	14.5	11.6	8.7	5.8	2.9	290
	.108	.27	1.08	2.16	2.7		25.5	21.25	17	12.75	8.5	4.25	425

b

Figure 7-4. (*continued*)

- W (window)—windowing in each selection; anything entirely in the window gets picked
- C (crossing)—anything inside or crossing the walls of the window gets selected
- Box—can be a window if started on left or a crossing if started on right
- AU—automatic pick if pointing to object, W if began to left of object, C if began to right of object; AU is in effect until all selections are made
- P (previous)— manipulating the same selection set again
- L (last)—most recently added object
- R (remove)—remove unwanted elements in selection set
- A (add)—add more
- U (remove last)—remove last element selected

Keep all these methods of object selection in mind and use the most versatile in order to avoid having to reselect the mode contin-

TEXT SIZE CHART

SCALE	1/32"	1/16"	1/8"	3/32"	3/16"	1/4"	3/8"	1/2"	3/4"	1"	1½"	3"	LEROY SIZE
	2.56	1.28	.64	.86	.43	.32	.21	.16	.106	.08	.053	.0267	80
	3.0	1.6	.8	1.066	.533	.4	.266	.2	.133	.1	.067	.033	100
	3.84	1.92	.96	1.28	.64	.48	.32	.24	.16	.12	.08	.04	120
UNITS	4.48	2.24	1.12	1.5	.75	.56	.37	.28	.186	.14	.093	.047	140
	5.6	2.8	1.4	1.86	.93	.7	.465	.35	.23	.175	.117	.058	175
	6.4	3.2	1.6	2.14	1.07	.8	.53	.4	.266	.2	.133	.067	200
	7.68	3.84	1.92	2.56	1.28	.96	.638	.48	.319	.24	.16	.08	240
	9.28	4.64	2.32	3.1	1.55	1.16	.77	.58	.386	.29	.193	.097	290
	13.6	6.8	3.4	4.54	2.27	1.7	1.13	.85	.565	.425	.283	.14	425

c

Figure 7-4. (*continued*)

uously. For instance, most often, editing involves groups of objects, and selection must be made repeatedly. Instead of giving the MOVE command, then W once, selecting, then W again, then selecting, then C and selecting again, issue the move AU and keep selecting with any mode until done.

6. Blocks/Reuse of Drawn Images

One of CADD's most efficient features is its ability to reproduce a drawn image more than once (see Figure 7-6). Using this feature to the fullest is the key to CADD efficiency. Reuse of drawn images can be as simple as using a symbol over and over, a core framing, or an entire basic framing plan. Mirroring of symmetrical schemes is based on the same principle.

SYMBOL SIZES

SYMBOL SIZE	INCHES	3"	1 ½"	1"	3/4"	1/2"	3/8"	1/4"	3/16"	1/8"	3/32"	1/16"	1/32"
	1/4" DIAMETER	.083	.167	.25	.33	.5	.665	1	1.33	2	2.66	4	8
	1/2" DIAMETER	.167	.33	.5	.665	1	1.33	2	2.66	4	5.32	8	16
	3/4" DIAMETER	.25	.5	.75	1	1.5	2	3	4	6	8	12	24
	1" DIAMETER	.33	.667	1	1.33	2	2.66	4	5.33	8	10.66	16	32
	1 1/2" DIAMETER	.5	1	1.5	2	3	4	6	8	12	16	24	48
	2" DIAMETER	.666	1.33	2	2.66	4	5.32	8	10.66	16	21.32	32	64

SCALE — UNITS

Figure 7-4. (continued)

d

SYMBOL SIZES

SYMBOL SIZE	INCHES	M 1=250	M 1=200	M 1=100	M 1=25	M 1=10		1=60	1=50	1=40	1=30	1=20	1=10
	1/4" DIAMETER	1.59	1.27	.635	.159	.0635		15	12.5	10	7.5	5	2.5
	1/2" DIAMETER	3.2	2.54	1.27	.32	.127		30	25	20	15	10	5
	3/4" DIAMETER	4.76	3.8	1.9	.476	.19		45	37.5	30	22.5	15	7.5
	1" DIAMETER	6.35	5.08	2.54	.635	.254		60	50	40	30	20	10
	1 1/2" DIAMETER	9.5	7.22	3.81	.95	.361		90	75	60	45	30	15
	2" DIAMETER	12.7	10.16	5.08	1.27	.508		120	100	80	60	40	20

SCALE / UNITS

Figure 7-4. (continued)

e

```
Command: LINE
From Point: X,Y
To Point: X1,Y1
```

a

Figure 7-5. (a–d) Methods used to draw accurately. (a) Line is drawn by stating x, y coordinates of the starting point and the x, y coordinates of the endpoint. (b) Line is drawn by stating x, y coordinates of starting point, line length, and extrusion direction. (c) Line is drawn by stating starting x, y coordinates and the displacement in the x, y directions. (d) Line is drawn by using the OSNAP feature to snap to and from known points on existing entities. *Note:* Line can be drawn by combining the above methods.

7. Display Commands

Knowing the best way to scan around a computer-generated drawing is essential. ZOOM, PAN, and VIEW commands are key, as is their well planned use, which can subtract time from the editing process. While drawing regeneration frequency and time depend on the speed of the computer and its zoom capabilities, in most cases, smart zoom usage can save time. (Related commands: REGENERATE, REDRAW, LAYER ON/OFF/FREEZE)

8. Exiting the Drawing

QUIT will discard any changes made, and SAVE will update the saved version of a drawing on the computer's hard drive from

20'-0"

40°

X, Y

```
Command: LINE
From Point: X,Y
To Point: @20<40
```

b

Figure 7-5. (*continued*)

within AutoCAD's drawing editor. END saves and exits the current drawing.

9. Using the Crosshairs as Drafting Tools

- ORTHO ON/OFF—to draw only horizontal or vertical lines (ON)
- SNAP ROTATE—to draw lines at a specific angle and lines perpendicular to that angle
- GRID—to guide layout of a specified grid
- BLIPMODE—leaves a mark at each selection point (it disappears at the next redraw)
- SNAP—forces crosshairs to snap to points at specified intervals
- OSNAP—forces crosshairs to snap to specified points on existing elements such as endpoint, midpoint, intersection, etc.

```
Command: LINE
From Point: X,Y
To Point: @18,24
```

c

Figure 7-5. (*continued*)

B. THE DRAW AND EDIT COMMANDS

After a thorough level of understanding of the above basic concepts is attained, learning the working and editing commands should not take long.

Chart 7a lists the most frequently used draw commands with a brief description of each. Chart 7b lists and describes the most common editing commands. Chart 7c lists commands that return information. Chart 7d lists commands that manipulate the screen.

Reading the description of each and trying to manipulate them is the best tutorial.

CHART 7A. MOST USED DRAW COMMANDS

1. ARC Draws an arc of any specifications using several
 methods.

2. BLOCK Creates a single entity from one or a group of
 [WBLOCK] objects that may be used again and again within

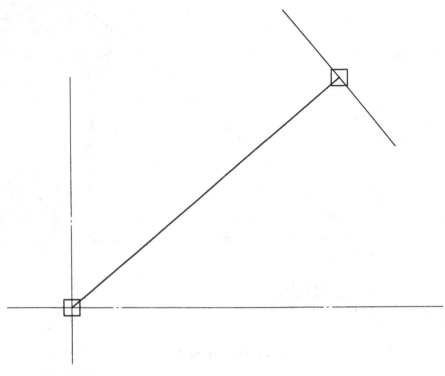

```
Command: LINE
From Point: Osnap Inters
To Point: Osnap Midpoint
```

d

Figure 7-5. (*continued*)

that drawing (writes this to a drawing file to enable use in other drawings). When "redefined" (or changed), all blocks on that drawing change automatically.

3. CIRCLE Draws a circle any size with several methods of specifying its dimensions.

4. LINE Draws a line of any length or at any angle using several methods of specifying beginning and end points.

5. POINT Draws a single point, usually used as a marker.

6. SOLID Draws a filled-in angular shape (polygon).

Figure 7-6. Reproduction of symbols with varying dimensions.

7. DOUGHNUT Draws a filled-in circular shape.

8. TEXT Draws lettering/text any size with various options
 [DTEXT] regarding placement, angle, etc.

9. PLINE Draws lines of a given solid thickness with various
 segments acting as one line.

10. ELLIPSE Draws an ellipse.

11. POLYGON Draws a polygon.

CHART 7B. MOST USED EDITING COMMANDS

1. ARRAY Makes an array or multiple copies of a drawn entity
 in a rectangular or circular pattern.

2. BREAK Breaks an entity into two parts.

3. CHANGE Can change an object's properties or position in space.

4. COPY Copies drawn objects one or more times.

5. DIVIDE Divides an object into a specified number of parts/places-markers.

6. ERASE Erases objects.

7. EXPLODE Replaces a block acting on a single entity with a group of objects that are a sum of its parts.

8. EXTEND Extends a line or arc to meet a specified border.

8a. FILLET Fillets two lines with a specified radius.

9. HATCH Cross-hatches an enclosed area.

10. INSERT Inserts previously created blocks.

11. MIRROR Creates a mirror image of an object.

12. MOVE Moves an entity or group of entities from one location to another.

13. OFFSET Offsets a line or curve by a specified distance (creating parallel lines or curves).

14. ROTATE Rotates an object or group of objects by a specified angle.

15. STRETCH Stretches an object in any given direction.

16. TRIM Trims lines at a given boundary.

17. U (Undo) Undoes any CADD operation step by step, with the last being first.

18. SCALE Changes size of a selected object (blowup or reduction).

CHART 7C. COMMANDS THAT RETURN INFORMATION

1. AREA Gives the area of a specified enclosure.

2. DIST Gives the distance between two specified points.

3. LIST Lists data on selected entities.

4. ID Gives the coordinates of a specified point.

5. MEASURE Measures a specific distance along the length of a selected object.

6. TIME Gives time of drawing start and total editing time.

7. STATUS Displays drawing specifications.

8. HELP Gives help with a command name by giving brief description of what command can do.

CHART 7D. MANIPULATING THE DISPLAY ON THE SCREEN AND ADDITIONAL DRAWING GUIDES

1. LAYER Manipulates or creates layers, and can remove them from the screen.

2. PAN Moves view on screen over.
 ['PAN] [Allows transparent pans while a command is in progress.]

3. REDRAW Fast screen cleanup—removes blips.
 ['REDRAW] [Transparent redraw.]

4. REGEN Regenerates screen; slower than redraw.

5. SHELL Exits to DOS.

6. VIEW Creates views which can be saved and recalled.

7. ZOOM Zooms in or out of a drawing.
 ['ZOOM] [Allows transparent zooming, i.e., in the middle of a command in progress.]

8. UNITS Allows selection of unit type, angle type, and angle measurement direction as well as the reading accuracy (number of decimal places).

C. THE MORE COMPLEX COMMANDS

Know that more complex commands exist, and are available for use. Chart 7e shows some of the more difficult commands. These need not be learned unless there is a specific project or occasion which requires their use. We do not seek to rewrite the AutoCAD or other CADD manuals in this chapter. When there is a need to perform the functions shown in 7e, the AutoCAD manual, practice,

and tutorials can help explain them further. Our purpose is to provide a reference guide which will allow quick insight as to which commands need to be understood, which commands might be crucial, and which commands are perhaps auxiliary in importance.

It stands to reason that the commands used most often will become the easiest to use. CADD drafters may be confused when confronted with an operation or technique they have not used in several months.

In these cases, it is best to refer to the CADD manual, or recruit the assistance of the CADD manager.

It is important for the CADD manager to watch the CADD staff, take note of the various approaches they use to basic problems, and point out the most efficient and desirable way to accomplish the task. This holds true especially when a project requires the repetitious performance of like tasks.

Again, AutoCAD, like other CADD systems, can be compared to a library. Mastery of a library system does not involve memorization of all the books titles and authors, nor their location on the shelf. It does require, however, that this information be accessible.

With CADD, knowing the basics is key, and from there, it is just a matter of practice.

CHART 7E. COMMANDS THAT REQUIRE FURTHER STUDY

1. ATTRIBUTES — When files generated from CADD drawings with specific database information are required, attribute utilization is necessary. Once elements are drawn with attributes associated with them, a file can be generated automatically, such as the one below:

Beam	Length	Location	Weight
W12	35'-0"	(130,35)	190
W14	48'-0"	(50,112)	211

Commands that Need Familiarity:

ATTDEF	Allows attributes to be defined.
ATTDISP	Controls attribute visibility.
ATTEDIT	Allows changes to be made to existing attributes.
ATTEXT	Extracts an attribute list to an ASCII file.

2. 3-D
 Commands

All structures are three-dimensional, yet drafting in 3-D is not used often in PC-based CADD systems. Until recently, AutoCAD itself was not well equipped for the three-dimensional world. Now, with release 10+, the 3-D capabilities of AutoCAD have become quite sophisticated. If 3-D work is not desired, it may be useless to train the staff. First, because it is difficult and requires time and practice to perfect. Second, if it is not used on a continuing basis, much will be forgotten.

When an office plans to use 3-D for some of its projects or presentation work, it is best to train CADD drafters who have the most understanding of the 3-D concept and the most experience. Perhaps a two-day training session with an additional three days of tutorials and practice can give a good drafter the basics.

The commands that need to be known are:

UCS	User coordinate system.
USCICON	Coordinate system icon to indicate *x,y,z* directions.
VPORTS	Viewports and their manipulation.
PLAN	Generates plan view relative to current coordinate system.
DVIEW	Dynamic visualization of 3-D objects.

Surface generating:

EDGESURF	Generates a 3-D surface when given 4 edges.
RULESURF	Creates a 3-D surface between 2 curves.
REVSURF	Generates a 3-D polygon mesh by rotating a curve around a given axis.
TABSURF	Creates a 3-D surface defined by a path and a direction vector.
3DMESH	Generates a 3D polygon mesh.
3DFACES	Draws 3-D planes.
3DPOLY	Draws 3-D polylines.
HIDE	Removes hidden 3-D lines from view, a lengthy process in complex 3-D drawings.

Autocad Release II with Solids Modeling Extension has additional commands that facilitate the

generation of 3D objects. These commands are not listed above, however they are important when working with 3D structures.

3. DIM		Dimensioning sequence of commands.
4. PEDIT		Various ways to edit polylines.
5. DXFIN		Loads a drawing from a drawing interchange file (DXF).
6. DXFOUT		Writes a drawing interchange file from within the drawing editor.
7. IGESIN		Loads a drawing from an IGES interchange file.
8. IGESOUT		Writes an IGES interchange file from within the drawing editor.

SUMMARY

Sometimes lengthy explanations confuse rather than help. Lengthy manuals, while necessary, often discourage individuals to become familiar with a software program. It is not always essential that the manual be studied thoroughly. With any CADD system, however, a thorough understanding of the basics is a must.

In AutoCAD, once the basics are understood, practicing each common draw and edit command is the best way to learn the system. When something is unclear, the AutoCAD manual is available as a reference. The more complex a command is the more practice and study is necessary. Most importantly, it is vital to be aware of what procedures are possible, but not necessarily to know exactly how to perform them. When a complex or infrequently used operation needs to be performed, the only step that should be taken is to refresh the memory on how to do it rather than wonder if this procedure is at all possible.

Chapter **8**

The Hard Copy: Plotting the Drawings

With the CADD system firmly established in the office, organized with menus and macros to suit its function there, and operated by a well trained staff, the production efficiency is guaranteed to be greater than that of manual drafting. Logical setup and effective leadership provide a smooth production flow with one final step remaining in the production cycle: the plotting of hard copies of the drawings.

Logically, once all work is completed on the computer, it would seem that plotting should be the easiest step. Yet plotting can often be the stage where panic abounds in an otherwise smoothly running CADD department. There is no reason it has to be that way, however, as this chapter will attempt to demonstrate.

Why are hard copies so important?

Architects and other related clients still need actual drawings to work with. The age of computerization has progressed far, but not so far that the design and construction professions can work solely with drawings called up on computer screens. As big as monitors are, and as high as their resolution may be, actual drawings are bigger and clearer, and they present the whole picture at once. Diskettes are of little use when the drawings are being checked or marked up.

In addition, after the work is submitted (whether it is 40% done or 90% done), all professionals involved will be issued a set of working drawings. Sometimes, especially when government work is being

performed, a significant number of consultants may be involved, all requiring a full set of drawings to work from.

Though any given job may be "finished," the work is not done until the drawings are plotted and sent out. The most critical problem that can beset an office beginning production on CADD is making changes until the very last minute. This way of working is not new to A/E firms. In the days of manual drafting, the mylar was taped to the drafter's board until minutes before the job was due to be sent out. An engineer would lean over the drafter and say, "Erase that solid line and replace it with a dashed one."

One of the first things that engineers/architects need to be told at their CADD orientation session is that they must change the way they hand out work, and that the old habit of altering plans up to the last minute must be broken.

The engineers or architects in charge must be given a cutoff time after which no changes may be made. How close this cutoff comes to the plotting of the drawings depends on the method of plotting employed by the firm and the size of the project.

It is very difficult to enforce the cutoff time rule unless everyone realizes that there is no other rational alternative. It follows, then, that priority should be given to certain drawings. For a project with 20 framing plans and four detail sheets, the priority may be to complete the 20 framing plans and have them ready for plotting the next morning, while four CADD drafters work continuously on the details until one hour before the deadline, when they stop and plot the drawings.

Because of the complex nature of A/E operations, it is often difficult to avoid last minute additions. Also, because plotters can malfunction, these last minute changes/finishing touches must frequently be added to the drawing by hand. This holds true especially for pen plotting, where a replot may take one to two hours. A typical oversight may be the revision date; just change it by hand. The computer file can be changed after the rush has passed.

CADD drawings ideally look clean and precise, so the impulse is to make them perfect whenever possible. A slight compromise in a last-minute situation can allow the work to be submitted on time and avoid plotting panic. As mentioned before, the cutoff time depends upon several factors:

1. The scope of the project; how many drawings are to be plotted
2. The size (number of bytes of memory) of the drawing files
3. The method used to plot the drawings

There are a number of options when plotting choices are being evaluated.

When choosing a plotter, the entire cycle of plotting should be considered, that is, from the time all work on the computer is done to the time all hard copies have been generated, including such tedious tasks such as trimming the plotted drawings.

For each of the various types of plotters available today, the following factors must be weighed:

- **Speed.** This is a very important consideration. Plot time calculations should include the preparatory time necessary (such as filling pens with ink or generating plot files for laser plots) as well as actual plotting time.
- **Quality.** The quality of the final product, the "construction documents," will be evaluated by clients and consultants and will reflect on the company which has produced them. Quality of linework (especially diagonals and curves) and lettering should be evaluated. Even tone, with crisp, dark lines is preferable.
- **Plotting Media.** Be sure that the plotter can produce plots on the necessary media. Most plotters can plot on bond paper and rag vellum. Drafting film or mylar has different properties and is not a possible medium with certain plotters.
- **Reliability.** No matter what the manufacturer claims, the best way to find out a product's reliability is by asking users how satisfied they are with the plotter in question. Plotters need service, thus a service contract for repairs and maintenance is advisable. Inquire about promptness of response to service calls and how often they are needed. (Is the plotter "down" a lot?)
- **Cost.** While the needs of the firm might point toward a laser plotter, the financial situation might rule out an expensive plotter. Although costs are decreasing, the purchase of high quality "fast mode" plotters may have to be put on hold.

There are four basic "roads" to the hard copy, which are examined below:

A. PEN PLOTTERS

When the PC-based CADD systems first became popular, the most common method of plotting was the pen plotter. Pen plotters can produce fine resolution, have a capability for color plots, with an end result of a high quality and elegant hard copy. Some of the earlier (and cheaper) models plotting at 14 inches-per-second (ips) would take about 1½ hours to plot an average (300,000 bytes) structural framing plan on 36" × 48" paper.

The later, more efficient models would cut that time in half. At present, continued improvements to pen plotters bring even faster pen speeds, up to 55 inches-per-second, which further reduce plot time. Unfortunately, because pen plotters function mechanically, i.e., draw each image line by line, they are still considered slow, causing a bottleneck at project submission time. For instance, with a small-scale project (under 10 drawings), a set of drawings could take up to 10 hours to plot. This figure must be increased due to preparation time and for margin of error. The following procedures add time to the operation:

1. Load the paper and fill the pens with ink, then make certain they are working properly.

2. Keep an eye on the plotter to make sure the pens do not dry up in the middle of the plot; stop the plotting to unclog the pens if problems arise.

3. Watch for a paper shift. If this occurs, a replot is necessary.

4. A sharp eye is needed for operator error detection, such as when an extraneous layer is left on mistakenly (this would also require a replot).

In all cases, add 30–50% to the plot time; for a job which should take 10 hours, figure 15 hours, which translates to a full two days of work. For the 15-hour job, a two-day cutoff time is required. This might seem an eternity to engineers and architects who are working down to the wire. (One alternative is to require a number of the CADD staff to put in overtime to finish the plots.)

No matter how experienced the person in charge of plotting is, some of the problems mentioned above will occur. Sometimes Murphy's Law will wreak havoc with the plotting schedule.

A project with fewer than 10 drawings is considered small, yet it delays the actual work time by 15 hours due to plotting. Thus, a mid-size or larger scale project simply cannot be plotted using one pen plotter.

One other very important consideration when submitting a set of working drawings is the final checking process. As changes and corrections are made, the diligent CADD drafters will carefully review the computer monitor and compare it with the marked-up drawings. The screen, because of its relatively small size, is not an ideal way to view the overall drawing. The 36″ × 48″ sheet is reduced several times and is not clearly visible.

Zooming and panning can be used, but, because some framing plans are repetitive, the zoom-view may be confusing when one is rushing to check the drawing for errors at the last minute. The best solution for quality CADD production is the final checkplot, whereby each CADD drafter can carefully review the plot, and, if need be, revise the drawing and replot it. Another option would be to issue final checkplots to the engineer for his last-minute changes or comments. At this time, the "hard copy" is still the key construction document.

Because the checkplot process would double the plot time to complete a submission, final checkplots are virtually impossible using only a pen plotter. Without checkplots to review, the probability of errors become greater and quality is harder to control. One option is to purchase a low-cost laser plotter (maximum size 11″ × 17″) for ½ size checkplots.

Some pen plotters are more reliable than others. The service record of the plotter for its first year of use usually predicts the degree of future reliability. In any case, relying on solely one pen plotter is not advisable. A backup is a good idea. The obvious solution is having another pen plotter of similar speed and quality in-house.

Another possibility is the establishment of an exchange system with another firm employing the same type of CADD system and plotter. Each firm acts as the other's emergency backup.

A third option is having a plotter service in mind that can handle the job. The CADD staff should be knowledgeable in the procedures involved in sending out plots (see Section D of this chapter.)

Aside from using pen plotters, there are three alternate plotting options available: Using a pencil plotter, using an in-house "fast

mode" plotter (electrostatic or laser), or sending out drawings to be plotted.

B. PENCIL PLOTTERS (PEN/PENCIL)

Acceptance of the pencil plotter in the United States has been gradual. Perhaps A/E professionals simply felt that the idea of plotting in pencil was bad, that it represented a regression to the inconveniences of manual drafting.

Though it is not for everyone, pencil plotting may be more desirable than it sounds. First, the market of the 1990s is sure to offer combination pen/pencil plotters for prices barely distinguishable from those of strictly pen plotters.

Since pencil plots are, of course, erasable, the whole system becomes more flexible. With pen and laser plots, the idea is that the plans are drawn in ink, permanently marking the paper. Pencil plots allow for easier editing—no replots, no wait time; if the change is approved, it can be drawn in on the spot and changed in the drawing file later.

There are still other advantages to pencil plotting. Not only is throughput faster (there is no need for pencil plotters to slow down —unlike pen plotters which must proceed at a speed which will prevent flow problems) but pencil plot line quality is fairly good (if leads no thicker than .5 mm are used.) These pencil leads, which are cheaper than pens, will not dry out, either. Pencil plotters do not have to be watched as carefully as pen plotters, but there is still a chance something will go wrong. Both pen and pencil plotters are mechanical means of plotting, quite different from the laser and electrostatic plotters described below.

Not everything about pencil plotting is appealing. Pencil plots may smudge, and too much force (and too soft leads) will leave graphite dust on the drawing. The use of color leads is almost impossible; it requires too much pressure. As for speed, compared with laser plotters, both pen and pencil plotters are a great deal slower, and many firms simply can not afford to wait so long for plots. In this case, regardless of the several desirable qualities pen and pencil plotters offer, firms must seek other options.

C. LASER AND ELECTROSTATIC PLOTTERS

It is not uncommon for a firm to turn to "fast mode" plotters after employing pen plotters for a while. Their astounding speed is their main attraction; any plotter taking less than 20 minutes to plot a complex drawing sounds great to a former pen plotter user. This type of performance is a dramatic improvement over that of pen plotters, but the market is broad, and plotters with plot times as low as one to two minutes for an E size plot can be found. The ideal "fast mode" model is one that takes no longer than five minutes to plot a typical drawing.

At this time, the two main types of "fast mode" plotters are electrostatics and lasers. While electrostatics and laser plotters vary in processing and plotting speed, and color output and quality, they do have certain characteristics in common. These plotters differ from pen and pencil plotters, which draw lines mechanically. Electrostatic plotters draw by transferring raster images onto plot media. In order to produce a raster image, the vectors generated by CADD need to be converted into a raster format, recreating an image line by line, converting graphic elements to dots. Once the drawing file is rasterized, it is "read" by the plotter, which transfers the image using an electronic charge to deposit toner (ink) onto the media. Resolution of electrostatic plots range from 200 to 400 dots per inch (dpi) with sheet sizes from A to E and color an option.

Laser plotters work much like electrostatics. They too require a rasterized format to plot a drawing. With a laser, however, the transfer of the drawing image is accomplished with a rotating drum that receives an electrical charge from a laser beam. The drum then picks up ink along the charged areas which is then transferred on to the media.

Speed is the main attraction of electrostatic and laser plotters. Since drawing density has less of an impact on plot speed than with pen plotters, the overall plot time becomes more predictable and significantly shorter. Another benefit is the elimination of worry over pens drying or skipping. In some models, the information is processed by the plotter, allowing other work to be performed on the computer while the plotter is at work. Where plotters do not offer processing, a "plot server" can be purchased. These devices drive the plotter from plot files on diskette. As for processing speed, some

models have as much as 20 times more throughput than pen plotters.

Fast track plotters are considerably more expensive than pen plotters, at about a 4:1 or 3:1 ratio. The prices will change, but the ratios will not vary too much. Even with electrostatic or laser plotters, there is more to producing a hard copy than just running the plots through. The first step is to make the actual plot files which the plotter will receive its instructions from. This must be done for the latest version of each drawing file. In a networked system, the latest version of each drawing will be within the system. Plot files can be made from any workstation in the network.

In standalone PC workstations, every computer's hard drive has different versions of drawing files. Because of this, the diskettes containing all the up-to-date work must be loaded into one or more of the faster computers, and then, through that machine, the plot files must be generated. After the plot files are generated, they can be sent either via the network to the plotter or, for non-networked systems (sneaker nets), they must be copied onto diskettes and brought to the plot station and sent to the plotter. In instances where the plot files are too large to fit on a single diskette, the files must be crunched, or compressed, which can take up to ten minutes each, depending on the size of the file. Then, when the file is loaded on the plot station or plot server, it must be extracted, which can again take several minutes.

It is evident that the steps that take a drawing from the screen to the mylar are numerous and can be time consuming.

One of the most common misconceptions a project manager has is that the plot runthrough time of x minutes per drawing is all the time needed to produce a plotted copy.

In addition to the routines of drawing file conversion to hard copy, there will be minor interruptions on occasion, such as pausing to load paper into the plotter or clearing a paper jam or other error message.

D. SENDING WORK OUT TO BE PLOTTED

Many firms that employ CADD for mid-to-large scale projects believe that purchasing a "fast mode" plotter is not cost effective. The

only alternative to fast plots in-house is to send out drawing files to be plotted by plotting services.

While plotting services were relatively rare in the early and mid-eighties, they have grown rapidly in number, with most providing daily pickups and dropoffs.

The volume of plots handled by these businesses is much greater than that in an A/E firm. It is not unreasonable to expect 50 drawings to be plotted within a 24-hour period.

There is administrative time spent by the CADD staff even when plotting is done outside the office. Plot files must be generated and copied to diskettes. Even when only the drawing files are sent out, it takes additional time for the CADD staff to copy the drawings to diskettes or tape and write specific instructions for plotting the drawing files. Pickup by messenger is often the means of "sending out" for plots; however, sending files via modem is sometimes possible. While a growing number of plotting services now have the capability to receive files by modem, keep in mind that this method may be time consuming when a great number of large files are involved.

Because of possible disk reading errors or other unseen errors, it is advisable to send a second, backup set of diskettes when sending out for plots, especially if the plotting service is located at some distance from the office.

It is best to establish a "working relationship" with the plotting company. Notify them in advance if you expect to send them a high volume job, so they can have the necessary staff available to do the plotting job. Under certain circumstances, weekend and evening plotting can be arranged. Make sure that the plotter service is notified of special plot parameters and has copies of custom fonts or shapes on file.

In summary, sending out jobs consisting of more than 10 drawings is usually a necessity when only one pen plotter is available in-house. Note that with preparation time, pickup, and delivery, and depending on the size of the job, an appropriate time period must be reserved for plotting.

A backup plotting service should be kept in mind in case the chosen plotter service has a problem meeting a deadline.

E. PEN ASSIGNMENTS AND PLOTTING HANGUPS

1. Charts, Rules, and Procedures Can Speed Up the Plotting Process.

Whether plotting a hard copy or sending work to a plot file, there are certain facts that a CADD drafter must know about each drawing. If this information is not readily available, the creation of the plot is further delayed because of the drafter's uncertainty.

In a mid-size CADD department, for a project with 40 drawings, there is little possibility that the CADD staff will recall all the pen assignments, scales, and sheet sizes of each drawing.

For pen plotters, it is best to create one or two standard pen assignments. That is, the color red always gets plotted with a fine pen, the colors blue and green with a pen of medium thickness, etc. Pen assignments can also be given for each project, but if the projects are similar in nature (e.g., all structural framing plans), one standard pen assignment should suffice.

These pen assignments (see Figure 8-1) should be posted near the plotter lest someone forget what they are.

The drawing scale should be written on every diskette label and the standard plot area should be established, such as "drawing limits" or specific "views" created to plot the desired area of the drawing.

A plot scale chart should be posted near the plotter to avoid hesitation (see Figure 8-2) in creating plots.

2. Printers as Plotters

The dot-matrix printer/plotter has recently appeared on the market as a possible alternative to high cost plotters. Most commonly, these printers are available in sizes A to C, with color optional.

The printerlike dot-matrix look of the hard copy, however, is disappearing, with some printers offering 720 dpi (dots per inch), emulating the resolution of pen plotters (1,000 dpi). Some even allow the user to switch between draft mode and fine mode. Print

PLOTTING PROCEDURES

1.) ALWAYS PLOT ON <u>PLOTTER</u> QUALITY MYLAR, VELLUM OR PAPER.

2.) USE THE PENS AND INK APPROPRIATE FOR THE SELECTED MEDIA.

3.) CLEAN ALL LIQUID INK PENS IN THE ULTRASONIC CLEANSER IMMEDIATELY AFTER USE.

4.) PLACE ALL EQUIPMENT BACK IN THE PROPER PLACE AFTER USE.

5.) WHEN A PEN IS WORN, REPLACE IT WITH A BACKUP PEN OF THE SAME SIZE AND CIRCLE THAT PENSIZE ON THE BACKUP ORDER LIST.

IN GENERAL, ALL PLOTTING SHOULD TAKE PLACE IN THE AFTERNOON HOURS. WHEN A PERIOD OF CONTINUOUS PLOTTING IS ANTICIPATED A PLOT SCHEDULE WILL BE ARRANGED.

LAYER	COLOR	PEN NO.	ELECTROSTATIC	LASER
① ⓪ ─────	1 [RED]	1	1	3
④ ─────	2 [YELLOW]	2	3	5
Ⓓ ⑥ ─────	3 [GREEN]	3	1	3
Ⓑ ─────	4 [CYAN]	4	5	7
⑧ ⑤ ─────	5 [BLUE]	5	3	5
Ⓐ ③ ─────	6 [MAGENTA]	6	3	5
② ⑨ ─────	7 [WHITE]	7	9	11
◯ ─────	8 [GREY]	8	1	3
⑦ ─────	9 [ORANGE]	9	6	3
Ⓒ ─────	10 [BROWN]	10	1	8
Ⓗ ─────	11 [DARK GREEN]	11	1	3
◯ ─────	12 [LIGHT BLUE]	12	1	3
◯ ─────	14 [PURPLE]	13	12	14
◯ ─────	15 [LIGHT GREY]	15	1	7

Figure 8-1. Posting pen assignments near the plotter expedites the plotting process.

PLOT SCALE	
IF DWG SCALE IS	PLOT AT
(INCHES)	
1"=10'-0"	1 = 10
1"=20'-0"	1 = 20
1"=30'-0"	1 = 30
1"=40'-0"	1 = 40
1"=50'-0"	1 = 50
1"=60'-0"	1 = 60
(MILLIMETERS)	
METRIC 1=100	1 = .1
METRIC 1=200	1 = .2
METRIC 1=250	1 = .25
METRIC 1=25	1 = .025
METRIC 1=10	1 = .01

a

Figure 8-2. Sample plot scale chart.

time is much less than with pen plots, more in the range of the electrostatic plotter.

Because of the typical construction document size of D or E, these printer/plotters are not yet acceptable for final plots in most A/E firms. Since they do have high resolution, they can be good for issuing check plots, though. In related fields, where reduced sizes are appropriate, these new dot-matrix printers can be utilized for final plots.

PLOT SCALE	
IF DWG SCALE IS	PLOT AT
(INCHES)	
1/32" = 1'-0"	1 = 32
1/16"=1'-0"	1 = 16
3/32" = 1'-0"	1 = 10.66
1/8" = 1'-0"	1 = 8
3/16" = 1'-0"	1 = 5.33
1/4" = 1'-0"	1 = 4
3/8" = 1'-0"	1 = 2.66
1/2" = 1'-0"	1 = 2
3/4" = 1'-0"	1 = 1.33
1" = 1'-0"	1 = 1
1 1/2" = 1'-0"	1 = .667
3" = 1'-0"	1 = .334

b

Figure 8-2. (*continued*)

3. Trouble Will Arise Even in the Best-Run CADD Departments

The larger the scope of the job to be plotted, the more hectic the office will be. Though it is expected that larger jobs take more time to plot, a cloud of panic and chaos will often descend upon the CADD department for major projects.

This is a time for good teamwork. The CADD team is under a great deal of pressure by the time the drawings are ready to be plotted. It is important that the CADD staff follow set procedures and avoid possible disaster.

One person should be selected to fill out plot sheets when the plotting is being sent out. This person must double check to make certain that the right drawings are being sent and that nothing is omitted.

For in-house plotting, a project drawing list should be kept near the plotter, as well as a diskette holder containing all the plot files. As plots are completed, they can be checked off the list.

Care should be taken especially when standalone workstations are used. Designate certain tasks to specific CADD team members, so that the job will be done in an orderly, complete fashion. In addition, each member must know what the others' responsibilities are, so they know where to go if they have questions.

SUMMARY

Plotting is the final step before work can be sent out to clients. It is therefore of great importance that the quality of the final product meet the firm's expectations, and that the production speed be satisfactory.

Pen plotters are a slower but less expensive way of plotting. Laser or electrostatic plotters are much faster, and also about three to four times as expensive. In either case, it is useful to have a backup system.

Sending work out to plotting services is an option more and more A/E firms are employing. Plotting services often offer same-day service, and daily pickups and deliveries.

Chapter 9

Disaster Handling

There will always be days when Murphy's Law will seem irreversible. In the CADD environment, this is liable to happen in the final stages of a rush job. While it is hard to foresee what new disasters lie just around the bend, you can count on disasters happening, and it is only wise to prepare for them.

The best tactic in any potentially deleterious situation is to try to prevent anything from occurring. Prevention is always preferable, but not always possible. The first measure to take is to review all possible points from which disaster may strike. The second step is to build in safeguards to buffer or negate a problem when it occurs.

A. SAFEGUARDS AGAINST DISASTER

Below are listed some possible causes (human errors as well as equipment malfunctions) of serious problems, as well as a few minor problems that occur frequently, and suggestions as to how they may be prevented or handled effectively.

1. The computer "freezes" in the midst of an editing session. The keyboard and digitizer do not respond. The only way to continue is to reboot the computer. Shutting off the machine will cause the work done on the drawing in the session to be lost.

Remedy. A strict practice of saving the drawing file (writing it to disk) every half hour can minimize the amount of work lost to under 30 minutes' worth. This significantly reduces the magnitude of the disaster. *Tip.* Before using macros or third-party software, save the drawing. Incompatibility or software bugs can cause the computer to freeze up.

2. The drawing being edited has a "FATAL ERROR" message and cannot be saved.

Remedy. While the potential for disaster is great, the save-every-thirty-minutes technique will assure that the drawing as it was no more than one-half hour ago is intact.

3. A power short, brownout, or blackout occurs. Work being edited is lost.

Remedy. Save is again the remedy. Some computers possess a special feature that allows enough time to save the drawing during a power surge or failure. A warning light flashes and a beep indicates that saving should be done.

4. The computer does not boot in the morning. The files in the hard drive are inaccessible.

Remedy. Always back up all files being worked on at lunchtime and in the evening. If the workstation is down, the drawing or drawings needing revision can be loaded from the diskette into another computer until repairs are made to the first computer.

5. The disk containing the latest version of a drawing file reads an error or the drawing cannot be accessed.

Remedy. In networked systems, diskettes are only needed in case of network failure. If the diskette reads an error, the file server or its latest tape backup will contain the drawing file.

In standalone PCs, the diskette is the "official" latest version of a drawing file. The weekly backup diskette may or may not contain the version of the drawing file needed (the date and time of the last editing session is usually indicated). To avoid losing work this way, do not clean out hard drive directories until after each weekly system backup. Thus, by checking the drawing log indicating which CADD drafter worked on that drawing last, or inquiring to that effect, the desired drawing version can be copied from that drafter's machine to a newly formatted diskette (the old, error-laden disk should be discarded).

Note. Always make sure that each computer is set up accurately for date and time, since these are often used to track drawings.

6. DELETE *.* can be mistakenly applied to the contents of the working directory instead of the contents of the diskette.

Remedy. A built-in path with the SAVE command to save a given drawing file to both the current directory and another, say C:\BACKUP, is one solution (see Figure 2-5). This backup directory's sole purpose is to protect work from disasters like misapplied DELETE commands. The other resident files in the working directory, such as batch files, should be saved on a diskette, ready to reload in minutes.

Software such as Norton's Quick Unerase can recover files if the attempt at recovery is made right away. Care must be taken with drawing files, however. Often, the file is recovered and placed back in the directory. It may seem to be a "healthy" drawing file, yet when editing is necessary, it cannot be accessed. When drawings are recovered this way, it is important to check the file by loading it directly onscreen.

7. An incorrect backup of a drawing file is made to a diskette; the user types COPY 45-PLAN1.DWG A; or COPY 45- PLAN1.DWG A instead of COPY 45-PLAN1.DWG A:, creating a copy of the drawing called "A". If this error is not noticed promptly, the next person working on 45-PLAN1.DWG will load it from the diskette and edit what is actually an older version of the drawing.

Remedy. List the directory of C:\DRAWING frequently. When an "A" appears, check the date and the number of bytes (see Figure 9-1). If the file is recent and takes up in the hundreds of thousands of bytes, the file is probably a drawing file. Rename A to A.DWG and check if it is a drawing that was recently worked on. Next check the working diskette for the date listed. If the error occurred a short while ago, a drawing with the same date, time, and byte size probably still resides in the directory. Careful investigation usually pays off.

8. Backdating a drawing accidentally; the computer's hard drive has 20-S5.DWG dated 3/10/90 and the diskette's version is 3/15/90. In the process of copying the file from the floppy to the hard drive, the incorrect command COPY 20- S5.DWG A: is given instead of COPY A:20-S5.DWG.

Remedy. Having all CADD drafters clean their directories only after weekly backups have been done will stop this from happening. While the floppy disk has been accidentally backdated, the drawing/drafter log will indicate who worked on that particular drawing last.

```
      ]
      Strike a key when ready . . .
      CC2BAT   BAT      177    3-27-90    8:32a
      43-PF    DWG   250290    4-06-90   11:08a
      MC       DWG     4531    1-06-90   11:21a
      43-PR    DWG   105446    4-06-90   11:44a
      54-S7    DWG    41560    4-10-90    1:24p
      43-FDN   DWG   479853    4-06-90    1:24p
      SIMP     SHX     6086    5-11-90    1:21p
      54-S9    DWG    39281    4-10-90    4:03p
      GRID     DWG     4569    2-08-90    9:22a
      MCROOF   PLT    69604    4-16-90    3:47p
      58-SK5   PLT   280676    4-17-90    1:22p
      MCROOF1  DWG    76016    4-16-90    6:06p
      MCROOF   DWG   157969    4-17-90   11:52a
      HANDLE   &TX        0    1-25-90    4:27p
      EDTSTR   LSP     8700    4-10-90    1:57p
      58-SK5   DWG   154536    4-17-90    1:18p
      COMPAQ   DWG     7410    5-08-90    4:07p
   ►  A              105446    4-06-90   11:44a
      ML       DWG     5115    2-16-90    3:16p
      LETTER   DWG     9458    5-11-90    2:36p
      B-UPC    DWG     4738    2-05-90    1:11p
      51-2FL   DWG   237701    5-02-90    5:27p
      CADSTA   PLT    85425    5-06-90   12:55p
      Strike a key when ready . . .
```

Figure 9-1. Investigation of suspicious file exposes error.

Their workstation's C:\DRAWING should have in it the latest version of the drawing. If nobody performed any work on the drawing recently, the backup set of diskettes will contain the latest version of the drawing.

Sometimes the reverse is possible, i.e., the drafter worked all day on the computer and now it is time to update the diskette. Instead of copying the latest version of the drawing to the floppy the reverse is done, backdating the computer.

Remedy. With an automatic save path to a backup directory, saving before ending the drawing assures that another copy of the file resides in C:\BACKUP.

9. The creation of two drawings with the same file name can be disastrous if one file copies over the other.

Remedy. Before CADD work begins on any new drawing, the CADD drafter should discuss the naming of the file with the CADD manager. This is important for two reasons. First, one CADD drafter may not know what work or new drawings are given to other drafters. Second, the engineer or project manager may give out a

drawing number that is already in use. While this causes no major problems if manual drafting is used, with computer-generated drawings, two files with a common name might lead to one file copying over the other and deleting it.

Remedy. As soon as anyone begins a new drawing, the drawing name should be penciled in on the official CADD drawing/job list that is pinned up on the CADD room bulletin board. This list can be referred to any time a new drawing is added.

10. Dumping large numbers of files into the computer's hard drive to make plot files or drawing interchange files can wipe out a resident file which may be needed in case of diskette error. Unfortunately, when the error occurs in the middle of a drawing file on the floppy disk, the drawing attempts to copy to the hard drive and then indicates an error. By this time, however, the "good version" of the drawing (300,000 bytes) is replaced by a partial version (125,000 bytes). This partial file is not even legitimate, and cannot be accessed.

Remedy. Always "file dump" into the C:\TEMP (temporary) directory. This way, if an error surfaces, the original drawing file is still intact on someone's C:\DRAWING directory.

11. Formatting the hard drive instead of the diskette in drive A: — this can happen when FORMAT C: is typed rather than FORMAT A:. Once this is done, the computer's hard drive is completely erased and reformatted.

Remedy. By renaming the FORMAT.COM file to FORMDISK.COM, and then writing a batch file called FORMAT.BAT (which calls on the FORMDISK.COM with drive A: only), this can be avoided. Typing FORMAT will then automatically lead to the formatting of A: (FORMDISK A:).

12. "Insufficient disk space." The computer runs out of bytes while in the drawing editor. The drawing cannot be saved.

Remedy. The CADD manager should encourage CADD users to delete unneeded files from the hard drive weekly (the day after a systemwide backup is done by the CADD manager). In addition, the "lost clusters" can be deleted using CHKDSK/F to create .chk files that should be deleted.

13. Drawing and other file access is sluggish.

Remedy. After months of use, the machine's hard drive becomes fragmented. At first, bytes from each file are stored together, but as soon as some files are deleted, new work may be saved to that space, which could be on another sector of the hard drive. An optimizer such as Norton's Speed Disk can reorganize information stored on the hard drive for quicker access.

14. "Out of RAM." The computer's random access memory has been depleted and the drawing cannot be saved. This can happen when RAM-intensive hardware or software is used. Graphic accelerators which provide fast zooms and pans such as the Metheus Board need 2 mb of RAM alone. When used with the new AutoCAD 386, 5 or 6 megabytes of RAM become essential.

Remedy. Before installing hardware/software, be sure that the computer has ample RAM to operate effectively.

15. Annoying recurring problems. Every piece of software and hardware has its own personality and can act up at times. For instance, the drawing file when ended may be lost forever for unknown reasons. On occasion, the digitizer's crosshairs may freeze and only the keyboard is functional. If a specialist/repairman is called, he/she usually cannot help if the problem is sporadic, because the problem will not be visible. Eventually, either things get worse and a part has to be replaced (maybe even the hard drive), or the problem is solved or a workaround is found.

Thus, each individual workstation, though using the same software and similar configurations, may behave slightly differently. The CADD drafter at a particular station can usually describe how problems occurred and what commands or components may be suspect.

Remedy. The CADD manager should keep a file on each CADD workstation, its setup, hardware, software, the AUTOEXEC.BAT file, the CONFIG.SYS file, and how the related hardware, digitizer, plotter, monitor, and printer are hooked up and configured. Slightly different clones may require small variations in configurations (they may show signs of bugs in the CADD software that do not occur on other workstation setups).

The workstations should have a sticker with the hard drive type

and an assigned station number (see Figure 9-2). The CADD manager can then track the configuration/setup/problems of station 5 or 10, not "Fred's old machine," etc.

It is ideal to have all workstations identical to the last detail, but it is not really possible. As new models, features, and upgrades arrive on the market, the purchase of new hardware is made according to the most attractive workstation combination on the market, as well as the best price.

Even when, in trying to be consistent, the same computer setup is purchased, the later-model components will behave in a slightly different manner and may be more sensitive to software bugs.

The workstation record file can be helpful in tracking problems or bugs, and when components malfunction and need replacement.

16. CADD operates too slowly.
Possible causes (check these):

Figure 9-2. Numbered stickers can identify workstations.

- Very large drawing database; try to clean drawing by purging it of blocks and unnecessary elements.
- If it is a network situation, there may be many users performing memory-intensive work.
- Conflicts or poorly functioning third-party software can cause slowdowns.
- Incorrect hardware configurations can cause sluggish response.

17. Work is being done in the wrong directory. This can lead to various versions of a drawing file existing on one machine. It can also lead to the temporary "loss" of a drawing file, i.e., a file that cannot be easily located. This problem is minor only if the file numbering system is not directory dependent (see Chapter 2), e.g., S-12.DWG in the C:\SCHOOL2 directory belongs to the school project while the S-12.DWG in the C:\HOTEL directory belongs to the hotel project.

Remedy. With one working directory for all CADD drafters (C:\DRAWING), a line at the end of the AUTOEXEC.BAT file (CD\DRAWING) can leave the user in the C:\DRAWING directory upon booting, thus reducing the chances of a CADD drafter working in another directory.

18. Misplaced or lost floppy disks; without a network the loss becomes very serious. When the CADD department is large or sprawling, it is possible to have difficulty locating a drawing file diskette. Although the rule of the CADD drafter keeping only one diskette at a time is followed, the CADD drafter may be distracted or misplace a diskette at times. When this happens, a frenzied search goes on until either the floppy is found or the machine where the latest work was done on the drawing file is located.

Remedy. When the diskette is not found, a new diskette can be used to copy the file from the computer with the latest version.

The danger is that somewhere in or around the CADD room there lies another floppy with the same drawing file (it may be found a few weeks later). All CADD users should be alerted to the fact that this missing diskette may turn up, but should not be used.

19. Drawing files or related files are too large to fit on a diskette (even 3½" 1.44 mb).

Remedy. It is good practice to trim drawing files of all unnecessary components. This reduces the size of the file, and speeds CADD operations. If the file is still too large, an archiving program (ARC.EXE is one example) or file compressor must be used to "crunch" the file onto a single diskette. An archived file must be "extracted" before it can be used again.

Experience is the best teacher in disaster handling; a major disaster will undoubtedly prompt new rules and new methods. Having some guidelines, such as the ones listed above, can help either avoid or quickly remedy disasters.

B. LEGAL ASPECTS

Sometimes disaster takes a different form: legal battles. The advent of CADD as a drafting and design tool brought on many changes in the A/E professions. Now there are many, many versions of the same drawing file. While a manually drafted structural framing plan, for example, is continually changed, erased, revised, etc., there will be only one original sheet. This drawing is stamped along with the other drawings in the set, and record prints are made for all subcontractors involved.

On the CADD system, original plots are made at each submission, but a growing trend is the exchange of diskettes among the design professionals (for checking, etc.). Now, it is a different task to assure the integrity of the diskette. There has to be a way to prevent the accidental or willful alteration of something by an outside professional, who may then claim to have received it in the altered form.

It should be understood legally by all parties that the information on these diskettes is for reference only, and is not the "official" original or finished product.

When the client, upon final submission, requires the computer files as well as the original "hard copy" set, care must be taken to assure that unauthorized changes to the computer file will not be possible in the future.

A recordkeeping set of diskettes "as submitted" should be kept in-house. This set reflects an exact copy of all files as given to the client(s).

SUMMARY

It is not always convenient to learn from your mistakes. There are times when mistakes are too costly, and have to be avoided.

With CADD work, there are numerous possible disasters waiting to happen at any given moment. A hard drive may be near failing, or one keyboard stroke in error may wipe out the contents of a directory.

Whatever the disaster, measures can and should be taken to either prevent or minimize its effects. Saving work every thirty minutes, for example, will leave no more than one-half hour's work lost if the computer should freeze up.

Checking to make sure there are no duplicate drawing files is important; sometimes these files are mistakenly created or imported, which can result in one copying over the other, losing it forever.

Computers have revolutionized the drafting/design fields forever, making staggering improvements in drafting efficiency. All drafters should remember that there is no hard copy until the drawing has been plotted. All work on the computer, no matter how nice it looks on the monitor, is intangible. The hard drive itself is intangible (except to manufacturers, perhaps). What CADD drafters have to keep in mind is that only extreme caution can keep these intangibles safe until they are ready to be plotted.

Chapter 10

Smooth Sailing?

Once the CADD department has been set up satisfactorily and is organized and functioning smoothly, there is no reason to sit back and relax. The operations as they are at that moment will not suffice in a year, or even a few months.

The scope of projects is constantly changing, software is continuously upgraded, and hardware setups improve. The world of CADD is truly a dynamic one. With ever improving technology, computer processing and plotting times are on the decrease. What seems amazingly fast today will inevitably be considered slow tomorrow.

Keeping the quality of CADD operations high, therefore, is not something to be achieved once, like climbing a mountain. It is an ongoing effort where there is no "final destination." Each upgrade is merely one step in an endless flight of stairs.

A. CADD SOFTWARE CHANGES/UPGRADES

Individuals have a tendency to adjust to something and then resist any changes or upgrades. If the currently utilized CADD program functions at an acceptable level, why revise it?

There are several reasons that changes/upgrades must be made continually.

First, if the CADD software currently employed has serious shortcomings, or is not suited to the tasks required of it, it may be time to look at other types of CADD programs on the market (which will undoubtedly be much more diversified and sophisticated than what was selling when the original system was purchased).

Even when the CADD system in use seems to be working well,

upgrades and new versions of programs should be purchased. Newer versions of any given software are usually improved in some way. In addition, if other firms are all an upgrade ahead, the in-house system will become outdated and perhaps incompatible with what everyone else is using. So the bottom line is not just to have the fastest and most sophisticated version of a program, but to be able to communicate with clients and other professionals in the field. It may be peer pressure, but it usually has good results.

Buying *every* upgrade may not always work to your advantage. Sometimes an intermediate version (5.0 for example) may be followed in only a couple of months by a "solid" upgrade (5.1) with bugs of the intermediary worked out, and new features offered. Upgrade numbering systems vary, but suffice it to say that a little research (finding out how many upgrades have been offered over the last three years) may help decide the urgency of a particular upgrade and distinguish it from one which is upcoming that is more desirable.

B. COMMUNICATION AMONG CONSULTANTS

Communication among A/E professionals using CADD systems is becoming an important consideration. Translation of a CADD drawing from one system to another is becoming a requirement on projects done with CADD.

At the start of a project, a CADD coordination meeting among A/E consultants on the team is needed to establish the guidelines and extent of CADD sharing.

There are many options and some limitations based on the various types of CADD software used by the team members (see Figures 10-1 to 10-4). One option is the actual sharing of a CADD database, i.e., using the same drawing data with each consultant contributing its share. For instance, the structural office provides the columns/beams, gridlines, and dimensions, while the mechanical engineers insert the HVAC system, the architects the architectural elements, etc. This way, all the professionals involved are hooked up to each other by network (if possible) or modem.

The advantage of this method is that the latest changes to a drawing are always available to all the consultants as soon as they are made. The disadvantages are that working with four or more consultants on one database needs considerable coordination, and

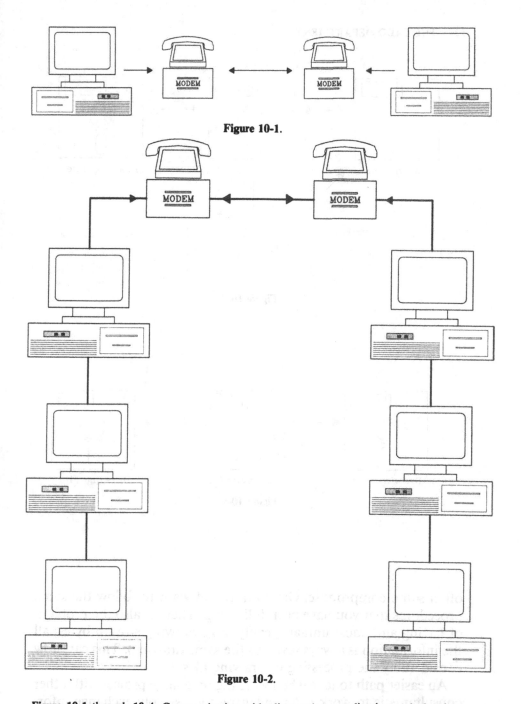

Figure 10-1.

Figure 10-2.

Figure 10-1 through **10-4**. Communicating with clients takes coordination and planning. These are some ways to exchange drawing information electronically: PC to PC through modem (10-1); PC network to PC network through modem (10-2); Drawing file to interchange file to translator to other drawing file (10-3); Drawing file to interchange file to other drawing file (10-4).

Figure 10-3.

Figure 10-4.

often some compromise. Others may not want to follow the same procedures that you have been following. There is also the problem of having an almost unmanageably large drawing size (in bytes; all the information is always saved to the same drawing). This can slow considerably the processing of drawing files.

An easier path to take when working on a large project with other consultants is to work independently, then simply exchange information electronically (via a modem) or by sending files on floppy disks. The least difficult scenario is when all consultants have the

same CADD software (same version) set up in-house. While using the same CADD software poses few compatibility problems, special fonts or shape definitions should be exchanged for complete transfer of information. Checking and overlays can become an easy task. Overlaying a structural plan over an architectural plan is a good method for checking for wall or column errors or interference. It is important to establish separate layers for the elements to be checked. This way, unnecessary elements can be cleared from the computer screen to allow the elements which do need checking to be viewed more clearly.

This type of drawing file information exchange becomes somewhat more problematic when different CADD (software) programs are involved. When CADD drawings are to be shared among consultants with different CADD systems, a drawing interchange file is necessary. In AutoCAD, for example, the DXF and IGES files are rewritten versions of drawing files (for the purpose of making them more universally recognized by other systems). Check the in-house system to see what types of interchange files it is able to create and accept. There are some CADD systems which need special translators to enable communication. Custom translators are often expensive.

In both cases, the translation may not be "pure" (perfect). There is usually a set of rules that have to be followed when translating. Not adhering strictly to them may jeopardize the purity of the translation.

There are often certain types of entities in one system that are not translatable. Certain CADD drafting techniques may impede translation.

Thus, it is important, first, to decide whether or not translation will be required; second, to test the translation method to check its accuracy and the length of the operation (some translators can take hours per drawing); and third, to make a list of do's and don'ts for the CADD drafters so the translating process will be as accurate as possible.

C. SCANNING

Integrating the hand-drawn work done by an A/E firm into the CADD bank can be slow and tedious. Details or sections previously

drawn may be similar to ones needed for a future project. One alternative to redrawing is scanning the drawing.

Scanning techniques have become quite sophisticated; a large hand-drawn sheet can now be scanned, resulting in a rasterized image of the old drawing. This rasterized image cannot be manipulated as a CADD drawing, however. It exists as an image on the computer screen that, with the aid of existing software, can be integrated with an AutoCAD drawing, resulting in a hard copy (plot) of both raster and drawing files. Limited editing can be performed on the rasterized image on the screen; for instance, if one note is incorrect it can be erased and replaced with a correct note.

The major drawback to raster images is quality. No matter how good a drafter is, hand drawings appear poor in quality compared with computer-generated drawings. Often, then, the raster image on the screen is used simply as a background to trace with the precise lines of computer drawn images and text. Depending on the complexity of the image being traced, time may be saved with this technique.

Once traced, the raster image can be removed (rubbed) from the screen, leaving only a pure CADD drawing.

D. IMPROVEMENTS

Ideas for improvements or additions to the CADD department can be generated from many sources. Most frequently, though, ideas for new features arise from need. This need for a certain capability is often expressed by CADD drafters, project managers, or the CADD systems manager.

CADD drafters' wish lists tend to include whatever can make certain CADD operations faster and easier.

Project managers may want takeoffs such as total steel for estimating purposes or for checking.

The CADD manager will note snags or inefficiencies in the everyday operations of the CADD department.

Where can you turn when a need arises? Look over the software programs on the market and see if any of them suit your needs. When the CADD manager is a good programmer, a custom program can be developed in-house to fill the requirement.

Programs written by others can often be useful. In some CADD

magazines, macros are published each month. It is a good idea to save these and store them under general headings. If a problem involving attributes arises, the Attributes file will contain all articles or programs related to that topic. A computer forum such as Compuserve can also give ideas to users. There are frequently helpful programs contained in this forum.

Sometimes, visiting or talking to other users can help improve an existing system. Watching how various systems are set up and how they function may serve to underscore a deficiency in your system or give ideas as to how further enhancements can be made in-house.

Inevitably, consultants working together will visit one another's office and tour the CADD department. Innovative ideas seen at work in another's office can inspire change at home.

Seminars and meetings held by professional societies are also a good source of new techniques and ideas. Computer software expos/shows can keep you up to date as well.

CADD users group meetings may also have the same effect. In talking with other users you can get a good idea of how happy they are with their setups, and discover at the same time how your system compares.

If the need is great and no program exists to perform the necessary function, a specialist or outside consultant may be brought in to custom write a program. While this may cost a lot, the return will probably be greater than the initial investment. Sometimes, a short but powerful program can save a great deal of valuable drafting or design time.

Take care not to burden the system with too much additional software. Any potential software addition has to be evaluated first. If it seems as though a program will boost quality and efficiency of CADD operations, a demo or further information would be practical. Once purchased and incorporated, a hands-on evaluation will ultimately decide the usefulness of the software.

Do not be surprised if third-party software looks great in the demo or on paper, but in actual use it reveals its user-unfriendly nature, in which case no drafter will want to use it.

Selectivity is a good policy. Do not buy up whatever is on the market "because it's there." Overloading with too many add-on programs, each with its own rules and procedures, will end up confusing the CADD drafters. Much time will be wasted as they try to figure out the next step.

E. FINANCES/CADD PAYBACK

Drafting film and lead are expensive, but not nearly as costly as computers, digitizers, plotters, and color monitors.

When a new drafter entered the traditional office, he needed a drafting table and a few drafting tools. In today's CADD environment, he/she needs an entire computer workstation. The difference in cost is significant. Worse still, a drafting table rarely needs maintenance or upgrading. CADD workstations, however, need service on a regular basis, as computer components tend to wear out or malfunction.

Thus, the total cost associated with production on CADD is high, and can sometimes be charged directly to the client.

Log systems, either programmed or manual, can be a convenient way to track what user works on what project for how many hours (see Chapter 1).

F. INFORMATION MANAGEMENT

While drawing database management is an issue that is addressed by third-party software written specifically for material takeoffs, etc., there is another type of information management problem that will inevitably come up with continued use of a CADD system. The problem is similar to that of an uncatalogued library. Now that many drawings, details, sketches, reports, and studies have been generated through the firm's CADD system, how can these be accessed in the future? Where can specific types of drawings be found? The straightforward project numbering system described in Chapter 2 assures that drawings grouped together by project can be located easily. But what if you wish to find all the drawings from CADD projects that show concrete waffle slab details, or want to know if a space frame design was ever drawn electronically? It may be tedious or often impossible to track specific information by backtracking.

For this reason, a program like dBase can be used from the start to categorize all projects, then within each project the individual drawings, and what can be found on them. For example, if drawing 23-S5 has an elevator core part plan and a curtain wall section, it would be listed in a query of drawings with those features.

After deciding which fields are to be used, a workable database

can be constructed. Filters and searches can provide sought-after drawings. A list of all drawings done last year with reinforced concrete can be had in seconds.

Once all projects are entered in a dBASE file (.DBF file), it can be edited weekly to include all new drawings and any new drawing information for previously entered drawings (see Figure 10-5). Since one of the key advantages of computer-aided-design and drafting is the capability to revise part or all of existing drawings, quick, specific information regarding existing CADD drawings is necessary.

To complete the file search efficiency, each finished project should have a corresponding CADD slide file of the drawings so that once the dBase query lists the drawings with the required information, the user can quickly view each CADD drawing on screen to see if any are appropriate.

G. THE FUTURE OF CADD

It is hard to see exactly where future technological developments will take the field of computer aided design and drafting, but some trends are already revealing themselves.

Take voice recognition in computers, for example. Will CADD

```
  Records      Fields      Go To      Exit                          9:22:05 pm
ZDDDDDDDDDDDDDBDDDDDDDDDDDDDDBDDDDDDDDDDDDDDDDDDDDDDDDBDDDDDDDDDDDBDDDDDDDDDDDDDDDDDDDDDD?
3DRAWING       3MATERIAL   3DTYPE                  3FILE       3PROJECT           3
FMMMMMMMMMMMMMXMMMMMMMMMMMXMMMMMMMMMMMMMMMMMMMMMMMXMMMMMMMMMMMXMMMMMMMMMMMMMMMMMMMMMM5
3S-1           3Concrete   3Waffle Slab            320-4SG     3Burgess Building    3
3S-3           3Concrete   3Waffle Slab            320-4S1     3Burgess Building    3
3S-5           3Concrete   3Waffle Slab            320-4S2     3Burgess Building    3
3S-7           3Concrete   3Waffle Slab            320-4S3     3Burgess Building    3
3S-9           3Concrete   3Waffle Slab            320-4S5     3Burgess Building    3
3S-11          3Concrete   3Waffle Slab            320-4S6     3Burgess Building    3
3S-13          3Concrete   3Waffle Slab            320-4S8     3Burgess Building    3
3S-1           3Steel      3Truss                  321-4SB     3Smith-Kline Factory 3
3S-2           3Steel      3Truss                  321-4S1     3Smith-Kline Factory 3
3S-3           3Steel      3Truss                  321-4S2     3Smith-Kline Factory 3
3S-4           3Steel      3Truss                  321-4RF     3Smith-Kline Factory 3
3S-5           3Steel      3Truss                  321-4SP     3Smith-Kline Factory 3
3S-1           3Steel      3Truss Detail           322-4S1     3Convocation Center  3
3S-11          3Steel      3Truss Detail           322-DET1    3Convocation Center  3
3S-12          3Steel      3Truss Detail           322-DET2    3Convocation Center  3
3S-13          3Steel      3Truss Detail           322-DET3    3Convocation Center  3
3S-14          3Steel      3Truss Detail           322-DET4    3Convocation Center  3
@DDDDDDDDDDDDDADDDDDDDDDDDDDADDDDDDDDDDDDDDDDDDDDDDADDDDDDDDDDDADDDDDDDDDDDDDDDDDDDDDDY
Browse   :A:\CADWORK           :Rec 17/17       :File :

                       View and edit fields
```

Figure 10-5. The browse mode, among others, of dBase allows the user to examine and edit records with ease.

users of the future simply issue verbal commands to produce graphics? Will the machines talk back?

Will artificial intelligence techniques allow a building to be designed and drafted mostly by computer and parametrics rather than by graphic input from CADD drafters?

Will true 3-D drawings take the place of projected views such as plans and elevations?

Will the standard D and E sheet sizes for architects and engineers be reduced to B and C sizes because of the sharper, clearer graphics of plotted drawings?

If the production of working drawings becomes simply a matter of answering questions regarding building specifications, will drafters still fit into the working drawing production cycle? This advance in computerized drawing would speed the process to a point where architects and engineers can produce a set of drawings without the help of technical drafters.

What will become of the media for storage of electronic data in the future? Will tapes and diskettes still be utilized for this purpose or will there be a revolutionary new storage method?

These questions remain unanswered as of this writing, but a few years hence, some of the answers will probably be manifest. So far, it does not look as if computers will replace architects and engineers (and related professionals), or drafters. CADD today needs people. CADD departments, if anything, are growing in size. As long as the building design and construction fields remain strong, so will CADD departments in the foreseeable future.

SUMMARY

Unfortunately, just when CADD operations seem set, and everything seems to be going well, it is already time to look to the future.

CADD software is constantly being updated, and new supplementary programs appear on the market with great frequency. Keeping on top of the market and making the right decisions in terms of which new software to purchase is important to maintain or improve the firm's efficiency.

Consultants on a team who use CADD must communicate with each other. A common drawing database may be shared when there are a small number of consultants. Otherwise, consultants can work

independently, exchanging information electronically at given time intervals.

Hand-drawn work can be integrated with automated work through the use of scanners, allowing it to be used in CADD drawings, with some limitations. At worst, a scanned detail can be used as a guide over which a CADD-generated version is easily drawn.

Suggestions for improving the CADD department's operations should be solicited from members of the CADD department and from other consultants. Additional software can usually rectify the inefficiency that has been pointed out.

With the initial high investment in hardware, and the later investments in software adding up, CADD becomes an area where finances have to be regulated. On large projects, special purchase of new equipment may be charged directly to the client.

An information management system, or drawing database, can help track projects. Through the use of filters, projects with certain specifications can be found. Though informal lists may at first serve as "databases," the use of a program such as dBase will provide the foundation for an effective long-term database.

Index

ARC, 89
Architects, 66
 need of, for hard copy drawings, 97
Archiving, of large files, 119
ARES, 92
ARRAY, 91
ASCII files, printing, 16
ATTRIBUTES, 94–95
AutoCAD, 70, 76, 78–96,
 3-D commands, 95–96
 attributes, 94–95
 blocks/reuse of drawn images, 84–87
 commands that return information,
 92–93
 DIM, 95
 display commands, 87
 draw commands, 89–91
 drawing scale and sheet size, 79
 DXFIN, 96
 DXFOUT, 96
 editing commands, 91–92
 exiting the drawing, 87–88
 grouping of elements in, 45
 IGESIN, 96
 IGESOUT, 96
 measuring distances, 81
 object selection, 81–84
 PEDIT, 95
 units versus real inches, 79–81
 utilizing layers, 81
Automatic generation of a structural
 framing plan, 74–75
Automatic units/scale/sheet size setup,
 71

Backdating, 113–114
Backup, 27
 of incorrect drawing, 113
 plotting service, 105
 second, 27–29
Banyan-Vines, 8
BLIPMODE, 88
BLOCK, 89–90
Blocks/reuse of drawn images, 84–87
BREAK, 92
Bugs, 39, 111

C:/BACKUPS, 5
C:/CAD, 3–4
C:/DRAWINGS, 4–5
C:/MACROS, 4
C:/SLIDES, 4
C:/SYMBOLS, 4
C:/TEMP, 5
CADD, future of, 129–130
CADD department
 communication in the, 31–42
 giving work to the, 67–68
 management of, 56–58
 physical environment in, 33–37
 troubleshooting in, 109–110
CADD directory tree, 3
CADD drafters
 selection of, 58
 training program for, 58–62
CADD drawing standards, 44–55
CADD drawings, last minute changes to, 98
CADD graphics standards, 46
CADD-group meetings, 38
CADD planning, 18–21
CADD room, 34–35
CADD software changes/upgrades, 121–122
CADD-tracking software, 5–7, 12, 128
CADD workstations
 clusters of, 35–37
 and data input, 2
 dispersal through office, 33–34
 identification of, 116–117
 in CADD room, 34–35
 monitor size of, 2
 resolution of, 1–2
 software installation, 2–3
 speed of, 1
CHANGE, 92
Changing directories, 15
Changing drives, 14–15
Checkplot process, 101
CIRCLE, 90
Column-grid intersections, 74
Communication
 among consultants, 122–125
 in the CADD department, 31–42
Complaints, sharing of, 38

Computer
 "freeze" of, 111
 nonbooting of, 112
Computer file management, 13
 changing directories, 15
 changing drives, 14–15
 copying, 13–14
 deleting files, 16
 formatting diskettes, 16
 listing, 13
 printing ASCII file, 16
 printing directory, 16
 renaming a file, 16
Consultants, communication among,
 122–125
COPY, 92
Copying, 13–14
Cost, of plotter, 99
Crosshairs, using, as drafting tools, 88
Custom fonts, 12
Custom menu systems, 11

Database managers, 12
Data input, 2
dBASE, 128
Delete, 112–113
Delete command, misuse of, 112–113
Deleting files, 16
Digitizing pucks, 2
DIM, 95
Directories
 changing, 15
 pitfalls of using, as project separators, 24
 printing, 16
 working in wrong, 118
Disaster handling, 111
 legal aspects, 119
 safeguards against disaster, 111–119
Disk error, 112
Diskettes
 formatting, 16
 proper labeling of, 40–41
Display commands, 87
DIST, 92
DIVIDE, 92
Documentation
 computerized, 41–42
 written, 40–41
Dot-matrix printer/plotter, 106, 108
DOUGHNUT, 91
Drafting, 21–22
Drafting tools, using crosshairs as, 88

Draw commands, 89–91
Drawing
 exiting, 87–88
 —renaming, for interdepartmental use, 26
Drawing file
 safeguarding, 26–27
 size of, 118–119
Drawing interchange file, 125
Drawing scale, 106
Drawing scale and sheet size, 79
Drawing sheet number, 22
Drawn images, blocks/reuse of, 84–87
Drives, changing, 14–15
DVIEW, 95
DXF file, 125
DXFIN, 96
DXFOUT, 96

EDGESURF, 95
Editing commands, 91–92
Electronic mail, 41–42
Electrostatic plotter, 103–104
ELLIPSE, 91
Engineers, 63–66
 and use of CADD system, 19, 32
Entities, use of, other than symbols, 54
ERASE, 92
Exchange system, 101
EXPLODE, 92
Extend, 92

Fast-mode plotters, 103–104
File name, investigation of, 114–115
Files
 deleting, 16
 renaming, 16
File server, 8, 27
FILLET, 92
Finances/CADD payback, 128
Floppy disks, lost, 118
Fonts, selection of, 49–50
Formatting, 16
 errors in, 115

GRID, 88

Hard copy, 97–110
Hard drive, fragmentation of, 116
HATCH, 92
HELP, 93
Hidden layer, as place to store drawing
 information, 42
HIDE, 95

ID, 93
Ideas, introduction of by CADD group members, 38
IGES file, 125
IGESIN, 96
IGESOUT, 96
Improvements, 126–127
Incompatibility, 111
Information, commands that return, 92–93
Information management, 12, 67–68, 128–129
INSERT, 92
Insufficient disk space, 115
Interdepartmental use, renaming drawing for, 26

Laser plotter, 103–104
LAYER, 93
Layer assignments, 44–49
Layers, wise use of, 81
Legal aspects of CADD, 119
Lighting in CADD room, 34
LINE, 90
LIST, 92
Listing, 13
Logging systems, 5–7, 12, 128
Log systems, 128

Macros, 12, 73–74
Management, of CADD department, 56–58
Marketing, 66–67
MEASURE, 93
Menu system
 features of, in selecting, 71–75
 periodic reevaluation of, 76–77
Metheus Board, 1, 116
MIRROR, 92
Monitor size, 2
Mouse, 2
MOVE, 92
Multitasking, 1

Networked system, drawings in, 27, 104
Network failure, 112
Networking, versus standalone, 7–11
Network management, 8–9
Non-networked systems, 25, 104
North directional arrow, 51
Norton Integrator, 16
Norton's Quick Unerase, 113
Norton's Speed Disk, 116
Novell, 8

Nth Engine, 1
Numbering system, importance of good, 21–24

Object selection, methods of, 81–84
Office staff, training, 62–67
OFFSET, 92
Operator error detection, 100
Organizers, subdirectories as, 3–5
Original drawing, location of, 25–26
ORTHO ON/OFF, 88
OSNAP, 88
"Out of RAM" message, 116
Outside CADD-support software, 11–13

PAN, 93
Panning, 101
Parametric features, in menu systems, 72–74
Parts libraries, 11
PCTools, 16
PEDIT, 95
Pen assignments, 106, 107
Pen plotters, 100–102
Personality conflicts, 39–40
Physical environment, of CADD workstations, 33–37
PLAN, 95
PLINE, 91
Plot scale chart, 106, 108–109
Plot spoolers, 12
Plot server, 103
Plotter, 34–35, 103
 electrostatic, 103–104
 factors in choosing, 99–100
 laser, 103–104
 pen, 100–102
 pencil, 102
Plotter services, sending work out to, 101, 104–105
Plotting media, 99
Plotting procedures chart, 107
Plotting process, speeding up, 106
POINT, 90
POLYGON, 91
Power failures, 112
Printing
 ASCII file, 16
 directory, 16
Project drawing list, 110
Project/file logging, 5–7
Project managers, 66

Project separators, pitfalls of using directories as, 24–25

QuarkExpress, 67

Record sets, 29
REDRAW, 93
REGEN, 93
Reliability, of plotter, 99
Renaming file, 16
Requests for changes/macros, introduction of by CADD group members, 38
Resident file, wiping out, 115
Resolution, 1–2
REVSURF, 95
ROTATE, 92
RULESURF, 95

SAVE, 29
Save, need for, 112
Saving, automatic, 29
SCALE, 92
Scales, converting drawings from one to another, 82
Scanning, 125–126
Secretaries and CADD department, 67
Shell, 93
Slow operation, 117–118
SNAP, 88
SNAP ROTATE, 88
Sneaker nets, 25, 104
Software, outside CADD-support, 11–13
Software/hardware malfunctions, 39
Software installation, 2–3
Software updates, 38–39
SOLID, 90
Speed of operation, 1
of plotter, 99
Standalone PC workstation
drawing file in, 26
drawing in hard drive in, 104
versus networking, 7–11
STATUS, 93
STRETCH, 92
Structural analysis packages, 12
Structural framing plan, 47
Subdirectories, as organizers, 3–5
Sun's PC-Network File System (NFS), 8
Symbol library, 72
building of, 50–54

Symbols
pictorial representation of, 54
sizes of, 85–86
use of entities other than, 54–55

Tablet menus, 72
Tablet overlay, 2
TABSURF, 95
Techniques, sharing of, 38
TEXT, 91
Text, selecting fonts, 49–50
Text editors, 12
Text size chart, 83–84
3-D commands, 95–96
3DFACES, 95
3DMESH, 95
3DPOLY, 95
Third-party software, 71, 76, 127
TIME, 93
Tracking systems, 5–7, 12, 128
Training program
for CADD drafters, 58–62
for office staff, 62–67
Translators, 12
TRIM, 92

UCS, 95
UNITS, 93
UNIX commands, 8–9, 11
USCISON, 95
U(UNDO), 92

Ventura, 67
VIEW, 93
Voluntary save command, 29
VPORTS, 95

Weidlinger Associates Menu System (WAMS), 73
Windows, 1
Word of mouth, communication through, 37–40
Working drawings, 97–98

Xtree, 16

ZOOM, 93
Zoom aids, 12
Zooming, 1, 101